To Jan,
I hope you enjoy the picture
and the stories!
love Sheila

Sat 7th Nov 2020

CW00551237

PARANORMAL WARWICKSHIRE

S. C. SKILLMAN

AMBERLEY

First published 2020

Amberley Publishing
The Hill, Stroud
Gloucestershire, GL5 4EP

www.amberley-books.com

British Library Cataloguing in Publication Data.
A catalogue record for this book is available from the British Library.

ISBN 978 1 4456 9826 7 (print)
ISBN 978 1 4456 9827 4 (ebook)

Typesetting by Aura Technology and Software Services, India.
Printed in Great Britain.

Contents

Introduction

I have heard, but not believed,
The spirits of the dead
May walk again

The Winter's Tale, Act 3, Scene 3

Did Shakespeare believe in ghosts and spirits? We cannot say for sure, but they make frequent appearances in his plays. It is known that he himself played the spirit of Hamlet's father many times, and it was 'the top of his performance as an actor', according to his first biographer. This is the ghost of whom Hamlet says:

The spirit that I have seen
May be a devil, and the devil hath power
To assume a pleasing shape.

But throughout the play Hamlet continues to agonise over the true nature of the spirit he has seen, despite the opinion of his sceptical friend Horatio, and he reaches different conclusions according to his state of mind.

Ghosts and spirits made excellent dramatic devices, but does their presence in Shakespeare's plays denote something much deeper? It's true that his county, Warwickshire, is saturated even today in strange events for which there is no scientific explanation.

Warwickshire has been my home for twenty-five years at the time of writing. I've grown to love this county's most iconic locations: castles, houses, and churches; and also some of its less familiar ones.

All these places have rich and complex stories to tell, as befits the county of Shakespeare.

Those stories bear witness to the fact that energy lingers in many places other than manor houses, abbeys and castles. They also tell of ordinary people going about their business in a day-to-day environment: shopkeepers and sales staff, pub customers, families in terraced houses, trespassing teenagers and busy rail commuters. Some of the stories are those the narrators kept to themselves, for a long time, for fear of being ridiculed.

Our task here is simply to listen to the stories that people tell and, like Hamlet, to explore the nature of these strange experiences both with our hearts and our minds, and reach our own conclusions.

Warwick

Guy's Cliffe House

Leave not the mansion so long tenantless
Lest, growing ruinous, the building fall
And leave no memory of what it was!
Two Gentlemen of Verona, Act 5, Scene 4

Clinging to a cliff alongside the River Avon north of Warwick, you may find the ruins of a mansion, in danger (until a few years ago) of fulfilling Shakespeare's words.

Many stories linger within these ruins. As you wander around you may wish to climb the gaping staircases, or stand on one of the stone balconies and gaze at the view across the river and over the surrounding fields, or imagine you see a shadowy figure flit past an empty window frame.

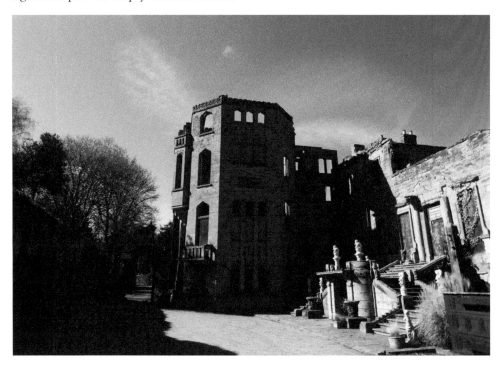

Full view of Guy's Cliffe. (Courtesy of Jamie Robinson)

Adrian King is the present custodian of Guy's Cliffe. He says:

'Years ago, 'my father shared a story with me, which first drew me to this estate. He said that whilst standing on the bridge further down the river at the Saxon Mill, looking toward Guy's Cliffe, he noticed a woman standing on one of those high balconies. It seemed to him that "she had a green aura around her". Then to his horror she threw herself off the balcony down onto the ground.'

This story piqued Adrian's interest and he began to research the history of Guy's Cliffe. Years later he was appointed custodian there.

The known story of the estate spans ten centuries. Well before any structures existed on the site, ancient Celtic people and, later, Christian hermits were attracted to the caves by the mystical qualities of the location. 16th-century historians described the area as an idyllic glade with 'many clear springs above a steep rock full of caves washed at the bottom by a crystal river'.

Adrian says that water has a strong influence on this place.

The attraction would have been not only rock – a wooded area with caverns in it – but springs as well. Those two aspects alone, rock and water, are spiritual; they would lend a reverence to the place. Very early on, a spring would have been attributed to a deity. The Romans came along and they melded their gods with the local deities.

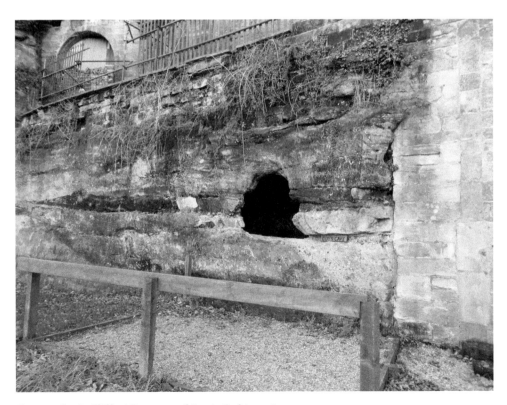

Cave at Guy's Cliffe. (Courtesy of Jamie Robinson)

Whether or not he was aware of these mystical connections, Samuel Greatheed, wealthy landowner and MP for Coventry, chose to purchase this land in 1751 and build a mansion upon it. From whichever direction you view the remains of the house today, its presence is powerful. The last members of the Greatheed family left in 1938, but the house remained intact up until 1952. We learn how it reached its present state later in this chapter.

Many of the curious tales of Guy's Cliffe surround the chapel of St Mary Magdalene next to the house (which is still in use today by the Coventry Freemasons, the owners of the property since 1980). Medieval historian John Rous, who was also chantry priest at Guy's Cliffe, writing in the year 1440, tells us that a Celtic monk called St Dubritious established the St Mary Magdalen Oratory at Guy's Cliffe in the year 600.

For a thousand years a small unimposing structure had existed here for the private devotions of a community of cave-dwelling hermits. Later reference is made to the chapel by three historians who visited the site during the reign of Charles I. They found 'an old decayed chapel now profaned in being made a woodhouse'. In the chapel they noticed a statue of the legendary hero Guy of Warwick.

The statue may be seen in the chapel today, hewn out of solid rock and showing him to be eight feet high. This, the most ancient part of the chapel, was probably constructed in the 12th century. In 1423, Richard Beauchamp, then earl of Warwick, established a chantry here, which thrived until the Dissolution of the Monasteries by Henry VIII, when the site passed into private hands.

Several strange anecdotes emerge from the chapel. One early evening Adrian and two companions sat in the chapel and saw 'a lightning bolt' shoot across the floor. He reports, too, that following the installation of a fire alarm, two electricians had returned there to do a repair.

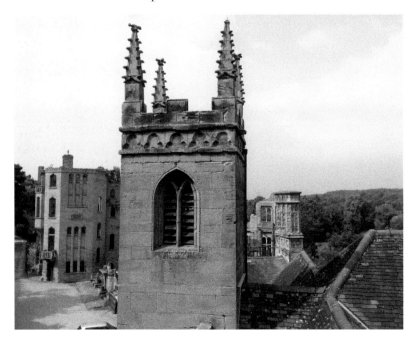

View of chapel at Guy's Cliffe. (Courtesy of Jamie Robinson)

Right: John Rous, chantry priest at Guy's Cliffe (historical gravure plate).

Below: Guy's statue in the chapel at Guy's Cliffe. (Courtesy of Jamie Robinson)

Chapel interior downstairs at Guy's Cliffe. (Courtesy of Jamie Robinson)

> They came to me and said, "You talking about this place being haunted?" They then swore they had heard footsteps overhead, clomping about upstairs on a wooden floor. However, all the floors in the chapel are carpeted. Hearing footsteps cross the upper floor is a common phenomenon here. Several visitors have reported this; occasionally they hear the sound of banging, as if someone is moving furniture about. If you run up there, you'll see and hear nothing.

Different light anomalies have also been observed in other areas of the site. 'Felice's Leap', a clifftop lookout named after a legend associated with Guy's Cliffe, overlooks the courtyard and the house. Adrian had taken a small party of visitors up there one evening, and they all saw 'little wisps of white like sparks going off from various parts of the property'. Another time, a visitor showed Adrian some photos she had taken, standing with her back to the entrance. She had captured a narrow pencil beam of light that shot up from the courtyard into the sky.

Curious incidents are also reported in the undercroft. Originally the Greatheed family described this as 'the mansion under the chapel'. On one occasion, Adrian hosted a group of visitors from the local council here. A member of the party – a lady – had unwisely remarked that the property would make a good casino; later she was almost pinned to the wall by a table which seemed to take on a life of its own.

Strange stories, too, arise from the coach house, where some visitors report the ghostly presence of a young stable boy in his early teens.

For centuries, the legend of Guy of Warwick has caught the imagination of many. The names 'Guy' and 'Guy's Cliffe' often recur in local street names.

Guy himself is said to have been born in Warwick. He built a formidable martial reputation during the time of Alfred the Great. He attracted the attention of Rohund, the Saxon Earl of Warwick, and fell in love with the earl's daughter Felice. After many heroic exploits elsewhere in England and abroad, he 'proved himself' in the eyes of the earl, came home and married Felice.

Later, feeling he had more to do, he set off for the Holy Land where he won many battles. Returning a penitent pilgrim, he made his way back to Warwick where, unknown to Felice, he occupied a cave in the cliff facing the river. The cave may be seen today, along with a number of others. He only revealed himself to Felice a short while before his death. Heartbroken, she threw herself from the clifftop adjoining the chapel. You may take Felice's Walk along the cliff. In a more recent attempt to explain Guy's behaviour (if we are to assume the story has some basis in historical fact), historians have speculated that perhaps he returned home with leprosy, which is why he chose to hide himself away.

Guy of Warwick's legend at Warwick Lane. (Courtesy of Warwickshire Libraries)

GUY, EARL OF WARWICK,
From a Basso Relievo in Warwick Lane. The Drawing taken from Mr Curtis's Window.
"Among all the remarkable stories of Guy, this seems the most plausible,

"Guy, Earl of Warwick, returning from the Holy Land in the habit of a Pilgrim, at a time when Athelstan "one of the Saxon Monarchs was in great distress for a Champion to fight Colbrand a monstrous Danish Giant "who in behalf of the Danes had Challeng'd any person the English should bring into the field: Guy "accepted this Challenge, & without being known to any but the King fought the Giant near Winchester, and "kill'd him, & the Danes yeilded the Victory, while Guy privately retir'd to a Hermits Cell near Warwick, "and there ended his days." *See Speeds Britannia p.33. Dugdale's Warwickshire, Stow. Book 5ᵗ p.190. Camden p.486. & c &c. Echard's History of England p.76. Maitland p.400 & Brittants, London.*

Publd April 2. 1791 by N. Smith No. 18 Cᵗ. Mays Buildings.

It is most probable that history has got mixed up with fable. As for Felice's demise, several stories tell of a lady jumping from a height at this location, including of course the account given to Adrian by his father.

Without doubt, Guy's Cliffe is a poignant and atmospheric ruin. Gothic stone tracery, an ornate balustrade, evidence of a theatrical architect, remain to tantalise visitors. The man most responsible for that Gothic flare is Bertie Greatheed, son of Samuel, born in 1759 and described as 'a child of the romantic era'.

Bertie inherited the property at the age of fourteen upon the death of his mother, Lady Mary, in 1774. In adulthood, he was to channel his creative energies into remodelling both mansion and grounds. He worked to beautify the northern aspect of the property adjacent to the river: the aspect everyone looks upon from the Saxon Mill pub.

It is not clear how many of the strange experiences reported at Guy's Cliffe – often with an aura of sadness – relate to Bertie Greatheed's time, but he did suffer a number of tragedies, including the early loss of his son (a talented artist). It is likely, too, that the river has claimed a few lives during the period of human habitation here.

Ghostly presences also make themselves known elsewhere around the estate, which in more recent times has been broken up. The stables became the International School of Riding, to the south; the Saxon Mill became a pub, bar and restaurant; the walled kitchen gardens became a plant nursery; and to the north of

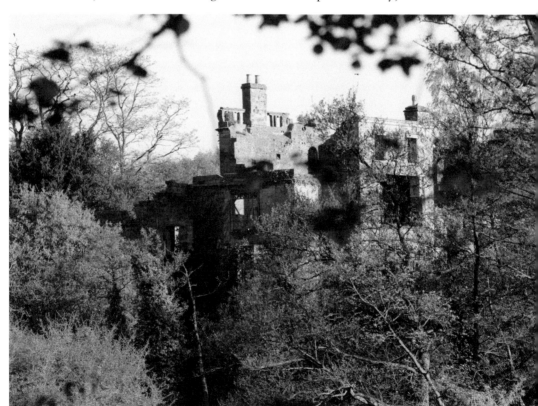

Guy's Cliffe from Saxon Mill. (Courtesy of Abigail Robinson)

the property another house, a private residence, stands between Guy's Cliffe and the Saxon Mill. In all these places curious incidents continue to be reported. The owner of the private residence, for instance, claims to have seen the apparition of 'a grey lady' walking up the drive.

Bertie died at Guy's Cliffe on 16 January 1826. His successors carried out various other pieces of work on Bertie's grand project. In 1882, the property passed to Lord Algernon Percy, second son of the 6th Duke of Northumberland, the last owner to make any changes to the house and chapel.

During the First World War the Red Cross used the house as a hospital. At the outbreak of the Second World War, the family left and the house became a wartime school for evacuee children. The family intended to return after the war, but they never did.

Thus began the swift and tragic decline of the estate. First, the family emptied the house of its contents. Then, plans by a consortium of businessmen to turn it into a hotel came to nothing. The next owner failed in his plan to demolish the house and build new homes on the site, and instead gained council permission to strip the property of all its removable features and sell them at auction.

Following this, the house decayed over a number of years until in 1955 the crumbling ruin, chapel, grounds and outbuildings were leased to the Coventry Freemasons. In 1980 they bought the property, which has remained in their ownership to the present day.

In 1992 Granada TV filmed a *Sherlock Holmes* episode here. During the final fire sequence, rotting beams and woodwork ignited in an area inaccessible to fire fighters, resulting in a much-reduced ruin.

It seems Bertie Greatheed may himself bear part of the responsibility for the house's final fall from grace; some say that his romantic architectural ideas would not have passed the scrutiny of today's structural engineers.

But who knows? It may also be his spirit that accounts in large part for the beguiling atmosphere of the ruins today.

The Saxon Mill

> This our life, exempt from public haunt,
> Finds tongues in trees, books in the running brooks,
> Sermons in stones, and good in everything.
>
> *As You Like It*, Act 2 Scene 1

The Saxon Mill was, in Bertie Greatheed's time, part of the Guy's Cliffe estate, situated upriver a short distance from the house.

The mill today is a romantic building that feeds the imagination, with the dank smell of drenched timber and ancient stone, the clanking of the great waterwheel, and the rushing of water over the weir beneath the bridge. All these combine with the spreading circles of tree reflections in the mill-pond, and beyond that the eerie ruin of Guy's Cliffe, to fill visitors with a potent sense of story.

Beyond the riverside eating area on the terrace, walkers may find the footbridge over the weir. White water gushes down, foaming the river. In spring and summer, the terrace overlooking the millpond – which is also a public right of way between

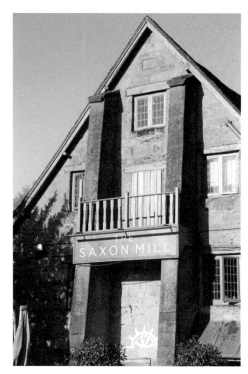

Left: Saxon Mill from Coventry Road, Warwick. (Courtesy of Abigail Robinson)

Below: View of Guy's Cliffe from Saxon Mill. (Courtesy of Jamie Robinson)

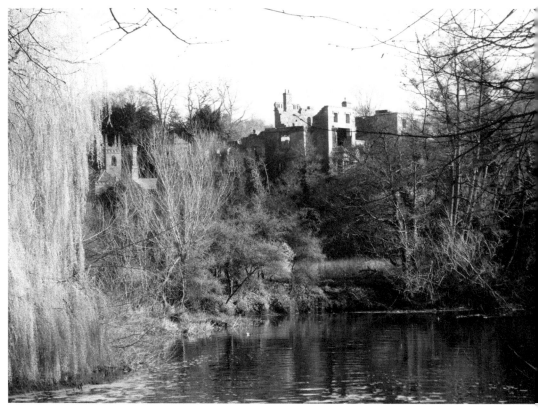

Coventry Road, Warwick, and Old Milverton Hill, and often used by dog-walkers – is filled daily with people eating, drinking, chatting and laughing, or just relaxing and contemplating the lovely surroundings of river, millpond and weir.

Nevertheless, from the Saxon Mill, curious anecdotes arise; either sightings of apparitions at Guy's Cliffe, or strong feelings of sadness and pity in relation to the ruins.

After crossing the bridge, walkers may approach Old Milverton Hill. Turning right once they have reached the field, they will find a riverside path, following the course of the Avon south, where an even more poignant view of Guy's Cliffe opens up on the opposite riverbank.

Coral provides this story for us. Her granddaughter Maddie was nine years old when she walked out of the restaurant after a meal with her grandfather Michael, and followed the route I have described above. They stood on the path opposite Guy's Cliffe and gazed across to the ruins. Maddie remembers the incident well, even though she is now a young adult. She says:

> I saw a woman standing on a balcony. I turned to granddad and told him this, and said, 'She's reading something'. Then I saw the woman fall.

Michael remembers that she was quite distressed. He himself felt puzzled and concerned. All he could say was, 'Nobody lives there any more.'

The original mill belonged to the Augustinian Abbey of St Mary's in Kenilworth. The abbey owned the mill until the Dissolution of the Monasteries. It then formed part of the Guy's Cliffe estate, and remained so up until the Second World War during which time it was known as The Old Mill. In 1813, as we have seen, Bertie Greatheed added the balcony, which provides the setting for the following story.

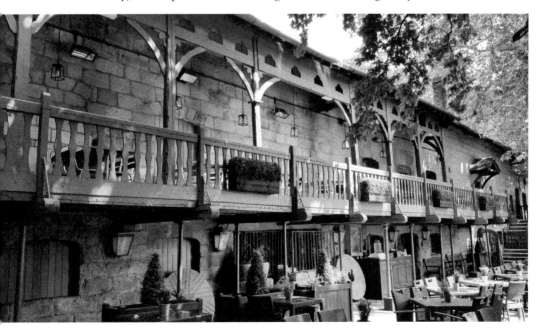

Balcony at the Saxon Mill. (Courtesy of Jamie Robinson)

James worked as a grill chef at the pub during the time it was owned by Harvester.

One hot summer night, when I was still quite new to the job, I was working on the grill in the front of house. I went to open the side door and let some air through. Out of the corner of my eye I saw a white figure pass along the balcony beyond the small window. Thinking someone had climbed up the outside stairs, I waited for them to come through the door. No one did. I looked out through the window, but there was no one there. About ten to fifteen minutes later I saw another figure moving towards the door. I poked my head out once more and still saw nothing. I told my colleagues, who said, 'that's Monty, the pub's ghost. He often knocks things over, and slams doors. He's quite entertaining!'

The mill continued as a working mill until 1938. It was converted to a restaurant and bar in 1952. The waterwheel, now restored, is visible to all who pass by, and the mill race can be seen through a glass panel in the pub floor.

During the spring and summer, the Saxon Mill's riverside eating area is packed with customers. It has undergone renovation following the change of ownership from Harvester to Premium Country Pubs. Structural alterations are, though, a matter of indifference to ghosts. Stephen discovered that the Gents are no exception to this rule.

A few years back, whilst in the pub, I headed to the Gents and saw a figure go in ahead of me. He was dressed in old fashioned clothes. I went in, and there was nobody there. Later, I spoke to the manager. I told him, 'I've just seen a man walk in before me. There was no one there. Do you realise this place is haunted?' He said, 'Oh yes, I know.'

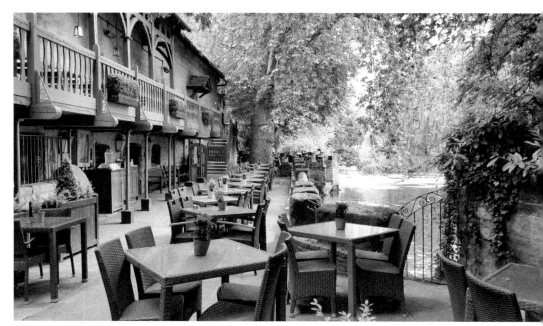

Seating area outside the Saxon Mill. (Courtesy of Jamie Robinson)

Gaveston's Cross

Nearby, Blacklow Hill became the scene of a notorious summary execution on 1 July 1312. Guy de Beauchamp, Earl of Warwick, had lured Piers Gaveston, King Edward II's favourite, to Warwick Castle. Guy had long wanted to get rid of Piers, who tormented him with personal insults and also exerted far too much influence over the king. Also Piers had defied commands to leave England and stay out, if he valued his life. The earl's men dragged Piers in a cart to Blacklow Hill, where they ran him through with a sword and beheaded him. The place of his execution is now occupied by Gaveston's Cross.

It was Bertie Greatheed himself who caused the monument to be erected on his land in 1821. Today the land is still in private ownership, and not open to the public. However, by special permission it is possible to visit Gaveston's Cross, in the heart of the woods.

The area where the monument stands is the scene of many curious tales. James recalls an incident from his early teens.

Some friends and I walked up into the woods opposite the Saxon Mill to try and find Gaveston's Cross. Being a bright summer's day I thought nothing of the potential fear factor. We hadn't got further than a few feet into the wood when day turned into

Gaveston's Cross, Warwick.
(Courtesy of Warwickshire
Libraries)

the pitch black of night, with a cold clammy feeling. Needless to say we didn't hang around long, and burst back into bright sunshine feeling rather relieved and more than a bit shaky.

James's story is corroborated by others who report unsettling experiences in this area. It is said that the execution procession of Piers Gaveston ascends Blacklow Hill to the place where he was murdered.

When Bertie Greatheed erected the monument, he arranged for it to bear these words:

In the hollow of this rock was beheaded on the first day of July 1312 by Barons as lawless as himself, Piers Gaveston, Earl of Cornwall, the minion of a pitiful King (Edward II) in life and death, a memorable instance of misrule.

Paranormal investigator Stephen Herbert, tells me:

I got permission from Warwickshire Police to do some filming at Gaveston's Cross. We were near the Cross when we saw shadowy figures.

His colleague, Simon Powell, believes these presences were responsible for breaking his laser torch. He explains that the torch he was using has a setting that spreads the lasers out, and 'something broke the beam next to me, like a person, but nothing could be seen'.

Apparitions reported in the area of the cross include a horse-drawn carriage, and a man with a hood on, but no face. This figure approaches people and disappears. Also visitors report unexplained hovering lights in the woodland, and they allege a sensation of 'being drawn in', and of presences 'surrounding you and watching you'.

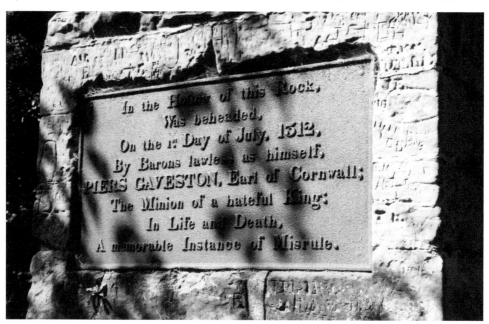

Inscription on Gaveston's Cross, Warwick. (Courtesy of Warwickshire Libraries)

Warwick Castle

My Lord of Warwick, here is – praised be God for it! – a most contagious treason
come to light, look you, as you shall desire in a summer's day.

Henry V, Act 4, Scene 8

All who approach Warwick from the south-east along the Banbury road will see the spectacular ancient fortress transformed into a stately residence for the Earls of Warwick. The south-east side of this magnificent castle commands a cliff on the bank of the River Avon beyond the medieval bridge, once the main entry point into Warwick.

Following the construction of a wider bridge in the 1780s, the medieval bridge was sealed off and partially demolished to form a picturesque ruin.

The castle, currently owned and looked after by Merlin Entertainments, was built on a site first chosen by Ethelfleda, daughter of Alfred the Great, who in the year 914 built the first fortification here to keep out the Danes. After 1066 William the Conquerer took it over as a site for one of the many motte-and-bailey forts he established throughout England.

Later, it became the home of the Earls of Warwick, several of whom have claimed prominent places in England's history. Today, many ghostly incidents are reported around the castle. One of the most well-known tales describes the apparition of Sir Fulke Greville in Watergate Tower. However, this story is no more than 100 years old, and is not mentioned at all in the writings of Daisy, Countess of Warwick, in the 1890s

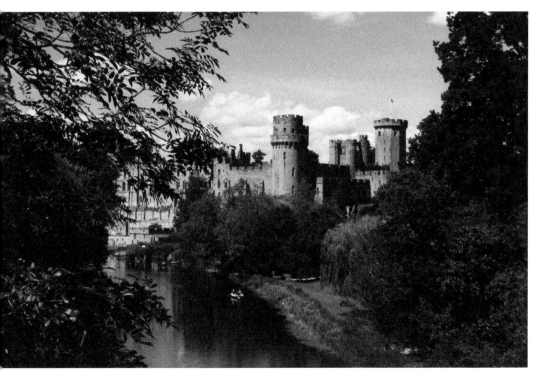

Warwick Castle from town bridge. (Courtesy of Jamie Robinson)

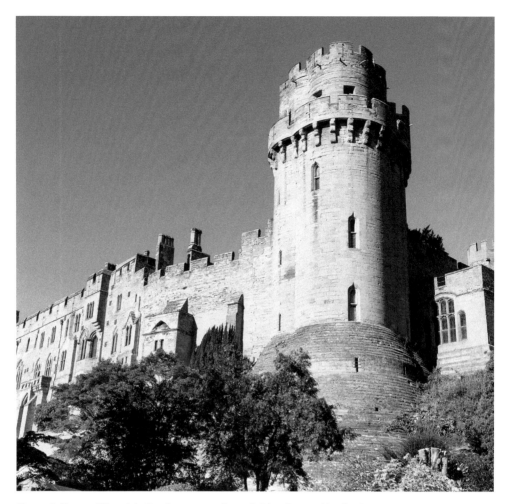

Caesar's Tower, Warwick Castle, as seen from Bridge Street. (Author)

and early 1900s. Being a keen spiritualist, Daisy would have been well-motivated to repeat a spooky tale if it came to her ears. Strong circumstantial evidence suggests it may have been invented to increase tourism to the castle.

Sir Fulke's time here spanned the years between 1604 and 1628, and he made many alterations to improve and beautify both castle and gardens. His death was a sad one: stabbed at his house in London by a resentful manservant, he lingered on for the next four weeks, suffering at the hands of inept doctors, before he died in agony. His body was brought back to Warwick and he was buried in the chapter house of St Mary's Church in the town, where you may see his tomb.

Probably the most notorious owner of the castle was Richard Neville, whose power lasted from 1449 to 1471. He became known as Warwick the Kingmaker, renowned for holding two kings prisoner during the course of one year, 1469: Edward IV in Warwick Castle and Henry VI in France.

Later on, the two Tudor kings Henry VI and Henry VIII left the castle to fall to ruins because of its associations with Richard III, who had also owned the castle for a period of time, and was the last of the Plantagenet dynasty whom they had replaced.

But Warwick the Kingmaker's fortunes changed when Edward IV's forces defeated and killed him at the Battle of Barnet in 1471. That is the battle whose extensive preparations we see in the brilliant waxwork exhibition *Kingmaker* at the castle.

This exhibition is the scene, too, of many curious incidents. Strange shadows and unexplained crashes, bangs and moans are reported. On one occasion, a coin was thrown towards a group of visitors by an invisible hand beyond the gates.

The strange tales persist when visitors have exited the Kingmaker. As we have seen, the installation of modern conveniences makes no difference to ghosts. Some visitors to the Ladies report a curious experience. They see a woman enter a cubicle. After a period of time, when others feel they must investigate, they find no one there. People also report seeing the taps turn on by themselves.

Ancient buildings go through many changes over the centuries, so no corner of the castle is necessarily free from curious events, and certainly not the state rooms.

After the Restoration of the Monarchy in 1660, Robert Greville set about creating a grand palatial residence at the castle. Today, visitors may tour the State Dining Room, the Red, Cedar and Green Drawing Rooms, the Queen Anne Bedroom, the Blue Boudoir and the chapel.

Remains of medieval bridge, Warwick. (Author)

On one occasion, Lesley Shepherd and her companion were visiting the Queen Anne Bedroom.

> We were alone in there for a short while. 'But I became aware of a foreboding presence in the corner of the room. My companion felt the same. When I looked in that corner, I had the strong impression of a Roundhead soldier from the English Civil War. We left the room straight away, and once outside I felt better.'

This room was formerly known as the State Bedchamber. In 1773, Francis Greville, Earl of Warwick, received the gift of Queen Anne's furniture, and renamed the room in her honour. The bed had been part of the suite in her State Bedchamber at Kensington Palace and was almost certainly her deathbed when she died there in 1714.

Back in the years between 1642 and 1651, well before Queen Anne's time, Civil War raged in England. At Warwick Castle, Robert Rich I, a Parliamentarian commander, succeeded Sir Fulke Greville and ordered that his exquisite gardens be swept away and used for gun placements. During that period the castle suffered much damage. Robert's troops were garrisoned there and would have treated the rooms with disdain. The State Bedchamber would have been one of the rooms that felt their presence. In 1642 Royalists besieged the castle, and some ended up in the dungeon, one scratching a note onto the wall.

After visiting the state rooms you may admire the castle chapel. The apparition of a five-year-old girl has been seen here, near the altar. She wears her blonde hair in ringlets. Most reports are from females, who claim that the little girl likes being here.

Throughout the castle, strange tales continue. In the rooms devoted to A Royal Weekend Party 1898, Tussauds wax models bring to life the atmosphere of that occasion. During the course of the tour, visitors may enter a red carpeted hallway with a big mirror at one end. Stephen Herbert tells me that a figure has been seen in that mirror, which does not reflect any of the living visitors, or waxwork exhibits.

The central personality, Daisy, Countess of Warwick, shines through this exhibition, from her earlier years of outrageous behaviour through to the awakening of her social conscience by the offended people of Warwick, after she had held an extravagant party in the castle to celebrate the installation of electricity, at which all the guests dressed as French courtiers.

In the Kenilworth Bedroom paranormal activity has been recorded. Daisy used it frequently in the late 1800s to hold séances. On 16 July 2016 journalist Chris Smith published a report in the *Stratford Herald* together with a photo taken by visitor Marie Hanna Dickson, showing the image of a man reflected in the information board in the Kenilworth Bedroom – when she knew herself to be alone in the room. The man appeared to be standing in the window.

Elsewhere in the castle, visitors and staff report extreme fluctuations in temperature; light anomalies seen with the naked eye; physical sensations of being pushed and grabbed; and the feeling of being watched.

In particular, the dungeons give rise to many eerie stories. In 2009, a site manager working on the dungeon feature encountered the apparition of a tall slim man in tunic and trousers. Others report the ghostly figure of a large man, believed to be a former jailer, seen behind the steel gate. Many describe poltergeist activity and the presence of 'a malevolent spirit with an aggressive nature'. Perhaps this is not surprising when we consider the brutal treatment many unfortunate souls may have suffered there in the past.

In Caesar's Tower, during a night vigil by paranormal investigators, 'the activity became so intense we had to leave the area'.

We may well speculate that perhaps this energy might owe its strength to the high emotional stakes by which its past inhabitants lived their lives, risking all for glory, power and wealth.

St Mary's Church

> The web of our life is of a mingled yarn, good and ill together.
> *All's Well That Ends Well*, Act 4, Scene 3

The Gothic tower of St Mary's Church first appears to all who approach Warwick from the direction of Stratford-upon-Avon or from Henley-in-Arden.

The decorated parapet at the top of the tower is 174 feet high to the tips of its pinnacles. From the viewing platform you may gaze down upon Guy's Tower at Warwick Castle, and, of course, from the top of that tower you may in turn enjoy a fine view of St Mary's Church.

The church foundations date back 900 years, and it is believed a Saxon church stood here before the Norman Conquest. The first Norman Earl of Warwick, Henry de Newburgh (who held the earldom 1088–1119) began a collegiate foundation,

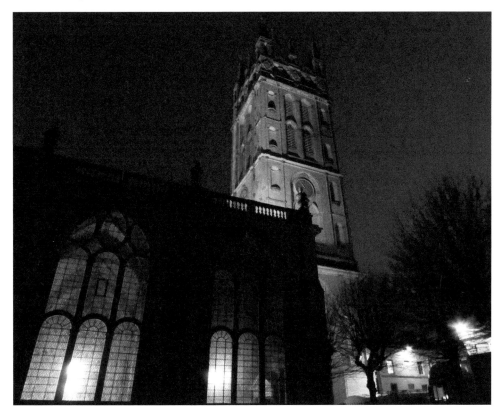

St Mary's Gothic tower, Warwick, at night. (Courtesy of Jamie Robinson)

modelled on the cathedrals of St Paul's, Lincoln, York and Salisbury. His son Roger completed it in 1123.

Earl Roger's foundation charter is still in the possession of the church, but of that original Norman church only the impressive crypt remains, with memorial stones and medieval grave covers below the feet of all who walk down there. Built in the 11th-century, it houses the tombs of the Greville family, the Earls of Warwick.

Also to be found in the crypt are the remains of a medieval ducking stool, formerly used for the correction of 'scolds' and to punish women for prostitution or witchcraft. The chair, with its victim strapped into it, mounted on two wheels, had a long shaft fixed to the axle. This was pushed into the water and the shaft released, tipping the chair up backwards. Sited here in the crypt, it serves as a chilling reminder of past brutality rooted in fear and superstition.

Ascending the steps we return once more to the choir vestry at ground level. The chapter house adjoins the vestry, and it houses the black marble tomb of Sir Fulke Greville, owner of Warwick Castle from 1604 to 1628.

Richard de Beauchamp, Earl of Warwick from 1401 to 1439, commissioned the final phase of medieval construction work: the elaborate Beauchamp Chapel, which houses his tomb.

With its rich ornamentation and glowing colours, the chapel today offers us a rare glimpse of medieval splendour, much of which was destroyed in churches throughout England after the Reformation.

Crypt of St Mary's Church, Warwick. (Courtesy of Jamie Robinson)

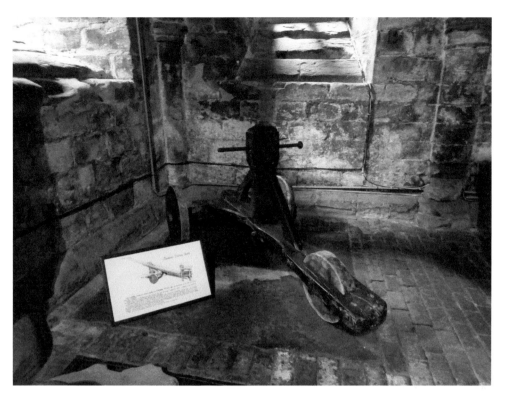

Above: Medieval ducking stool in crypt, St Mary's, Warwick. (Courtesy of Jamie Robinson)

Right: Sir Fulke Greville's tomb in St Mary's, Warwick. (Author)

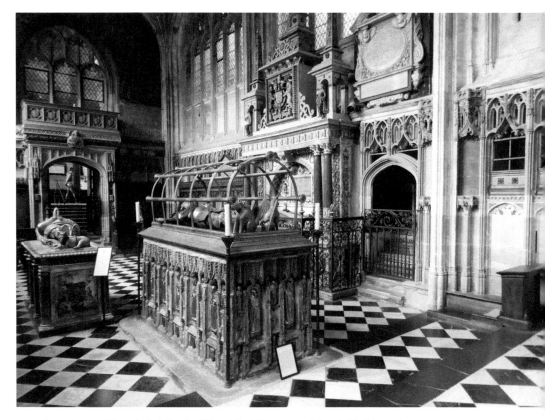

Beauchamp Chapel, St Mary's, Warwick. (Courtesy of Jamie Robinson)

Within the chapel you may find the tomb of Ambrose Dudley (earl from 1561 to 1590), whose brother Guilford married Lady Jane Grey. Also entombed in the chapel is Sir Robert Dudley, Queen Elizabeth I's favourite. He died in 1588 and here lies alongside his second wife, Lettice Knollys, not far from the tomb of their son, the Noble Impe, who died in infancy in 1584.

Of particular note, too, are the long scrolls of plainsong music carried by angels, while the feathered figures of other angels play musical instruments of the period. They may be seen high in the tracery of the side windows. On a number of occasions visitors have reported the sound of a ghostly choir singing psalms in the chapel when there's nobody there but themselves.

Standing in the nave and facing the chancel and altar, you may admire the vaulting of flying ribs, one of the finest examples on this scale in England. A mysterious dark figure is often seen at the altar in the evenings when the verger comes to close the church. When the verger moves down the aisle to ask him to leave, the figure disappears into the choir stalls and doesn't reappear. A search of the choir stalls shows them to be empty. So far no research has uncovered the history behind this figure.

In 1693 the nave, transepts and tower of St Mary's were destroyed in the Great Fire of Warwick, and later rebuilt in a Gothic design by Sir William Wilson, a sculptor from Leicester. Sir Christopher Wren was called in to advise on the best location for the new tower, and he recommended it be sited over the street. There it makes a powerful impact on all who approach.

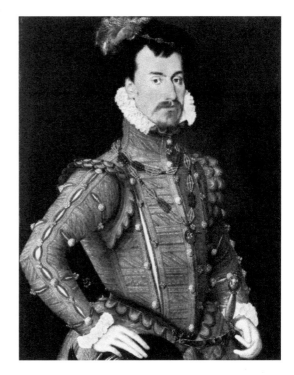

Right: Sir Robert Dudley. (The Wallace Collection (Bridgeman))

Below: The Noble Impe tomb effigy in Beauchamp Chapel. (Courtesy of Jamie Robinson)

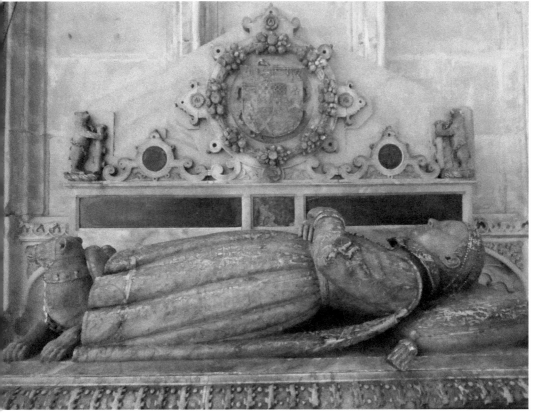

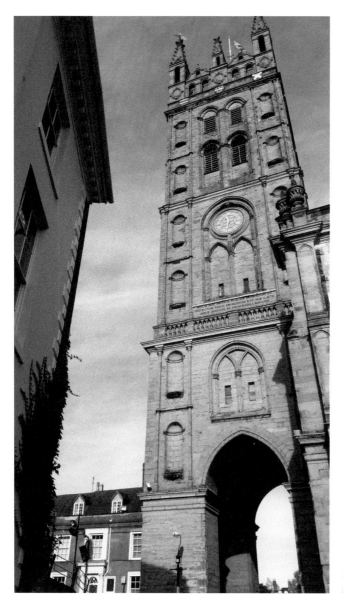

St Mary's tower sited over
street. (Author)

Around and behind the church building we are drawn into a different world: in the graveyard, many curious tales are told by those who walk among the tombstones, or along the path leading through to The Butts.

Liam, the Warwick tour guide for Ghosts Unlimited UK Ltd, has several stories to tell of St Mary's graveyard. They include the reported apparition of a rider in military uniform, mounted on a black stallion. A few visitors claim to have seen a female figure floating above the gravestones. Others have heard the faint sound of a child weeping at the south-eastern corner of the graveyard, with no one present to account for this. Examination of the gravestones in that part of the churchyard reveals two that might relate to the story: one of eight-month-old Mary Ann, and another of eight-year-old Joseph.

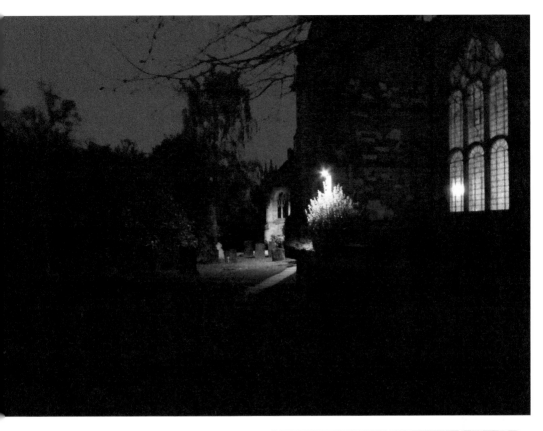

Above: Graveyard of St Mary's, Warwick, at night. (Courtesy of Jamie Robinson)

Right: Gravestone of eight-month-old Mary Ann, St Mary's, Warwick. (Courtesy of Jamie Robinson)

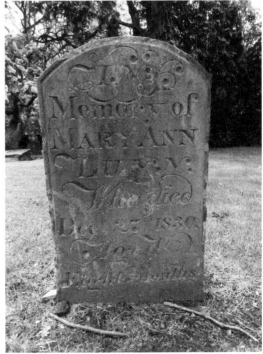

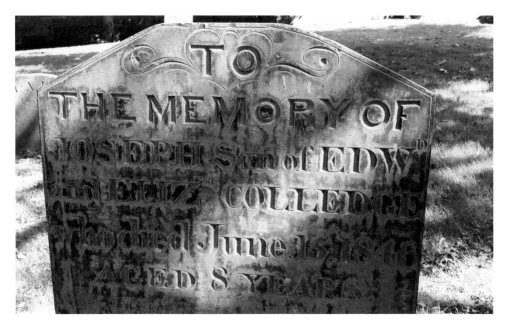

Gravestone of eight-year-old Joseph, St Mary's, Warwick. (Author)

Other sightings include the apparitions of two children playing hide and seek; a nun who is often seen crying; and 'a guard who lived 300 years ago who is still guarding Warwick'. In addition, the narrow alleyway at the south-east corner of the graveyard used to be sited 'outside the town wall' and serve as a place for duellists to fight and kill each other with impunity. The apparition of a dark large male figure has been reported here, an ominous presence.

St Mary's, Warwick, inspires many, representing artistic achievements, fine craftsmanship, and above all the richness and depth of our Christian heritage. Also, as is inevitable for an ancient site spanning 900 years, it includes a complex mixture of light and darkness in the human soul.

Thomas Oken's House and Lord Leycester Hospital

> To you, my good lord mayor,
> And your good brethren, I am much beholding;
> I have received much honour by your presence,
> And ye shall find me thankful.
>
> *Henry VIII*, Act 5, Scene 5

Close to the castle gate in Castle Street, Warwick, you will find Thomas Oken's House, built over 500 years ago by Thomas Oken, then Mayor of Warwick.

The property is owned by the Charity of Thomas Oken and Nicholas Eyffler, and is occupied by the Thomas Oken Tea Rooms, a popular venue for local residents and tourists alike. Jo Hobbs, the current owner of the business, reports several curious experiences in the house. She and her staff, and numerous customers, all feel the continued benevolent influence of Thomas Oken himself.

The story of this good-hearted merchant, whose life spanned the entire Tudor period, may be found on a plaque inside the ground-floor tearoom; on a brass memorial to Thomas and his wife Joan in St Mary's Church; and also as part of an exhibition and video presentation in the guildhall of Lord Leycester's Hospital.

Thomas presided over meetings in the guildhall, firstly as master of the Guild of Holy Trinity and St George, and later as burgess of the Burgh of Warwick. Then in 1557 he became Bailiff of Warwick (equivalent to the role of mayor).

Thomas's parents apparently were poor, but during his life he amassed a considerable fortune. Although he built the house on Castle Street that bears his name, he lived here for a short period only, as he also owned several other properties, but he returned at the end of his life. He married Joan, who predeceased him by some years, leaving him childless, and he died in this house on the night of 29 July 1573. He left his personal fortune to the town of Warwick – despite an undignified wrangle among his executors at his deathbed, all trying to get the money for themselves.

By his will, he benefited the poor people of Warwick, financed many local projects and also supported the choristers of St Mary's Church. Each year, a feast day is held to celebrate his memory in Warwick. His far-sightedness continues to be honoured today by the fact that income is still received from his original bequest.

Brass plaque to Thomas and Joan Oken in St Mary's, Warwick. (Courtesy of Jamie Robinson)

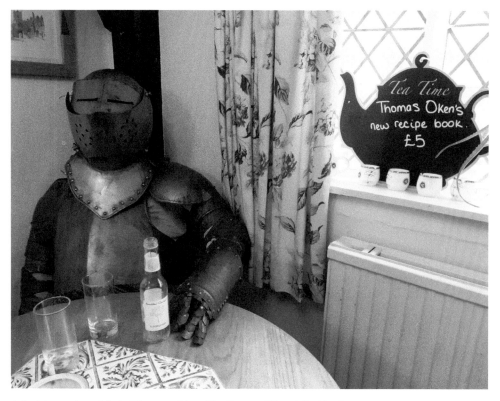

A knight at the table in Thomas Oken Tea Room, Warwick. (Author)

It seems appropriate therefore that the use to which his beautifully preserved house is put today gives pleasure to so many, over lunch or afternoon tea. It also teases the imagination by offering up a few unexpected incidents to staff and customers alike.

As soon as Jo took over the tearooms in November 2011, she began to hear strange stories from her young staff. First, let us go back to Jo's curious conversation with the previous owner of the business. 'He said to me, "You won't want to hang around here too long on your own after closing time, I can tell you."'

The vendor added that he had seen door latches shaking up and down on their own. Curious, Jo nevertheless took a sceptical view.

My young staff experience odd incidents much more than I do. I believe that young people have a particular sensitivity to the paranormal. In addition, though, several customers have reported seeing a dignified gentleman with fine clothes and a stick, who saunters into the room going from table to table and smiling benevolently at the customers. One visitor told me she was sitting in the big upper room and the chatter faded away, whereupon she heard the sounds of a medieval street market: carts and horses, vendors shouting their wares.

Jo went on to say that there are three supernatural presences in this building: a man, a child and an adult female servant – an older lady in a mobcap, dashing about downstairs.

Interior ground floor of Thomas Oken Tea Room, Warwick. (Courtesy of Jamie Robinson)

Several customers have described the small child, aged about four, sitting at the foot of the staircase on the ground floor. She wears a mob cap and looks Victorian. She plays with stones, perhaps a game of *five stones*. This phantom is only seen by pregnant ladies. Some say the child glances up and others have felt her tug at their skirts. Some of the waitresses have seen her too: it's a very quick fleeting glance.

Foot of staircase in Thomas Oken Tea Room, Warwick. (Courtesy of Jamie Robinson)

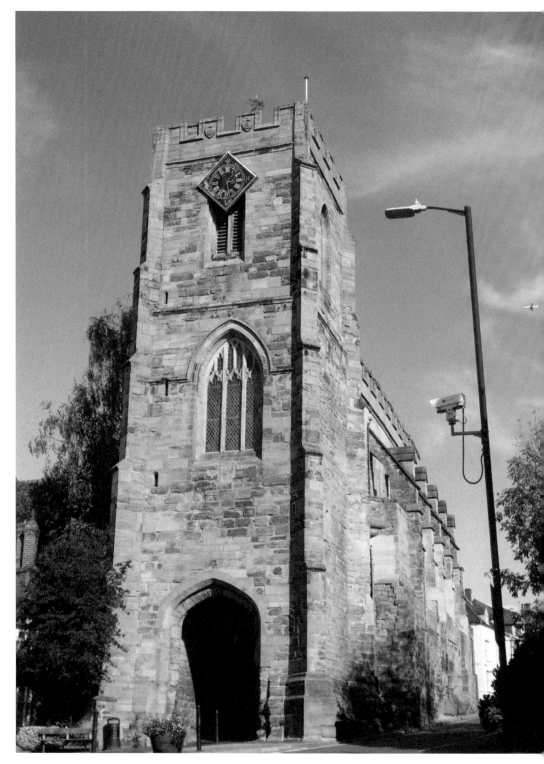

Lord Leycester Hospital Chapel at West Gate, Warwick. (Courtesy of Jamie Robinson)

Jo believes all the presences in the building are friendly.

> I often work alone late in the evening and never feel any fear. When I leave, I always say, "Good night. See you tomorrow morning!"

She adds, 'Thomas Oken was a wonderful man.' The affection with which she speaks of him is testament to the enduring reputation of this good-hearted and far-sighted Elizabethan merchant.

Those curious about the life of this 'dignified gentleman', whose energy lingers in the tearooms, may learn more by visiting the medieval guildhall and exhibition in Lord Leycester Hospital.

Entering Warwick from the south-west along the Stratford Road, we see a medieval chapel rising up on the Norman West Gate. A pedestrian path passes beneath the stone arch to the right of the old town walls, and beyond that will be seen the 15th-century half-timbered building that is Lord Leycester's Hospital.

This has never housed a 'hospital' as we would understand it, but rather, since Robert Dudley, Earl of Leicester, took it over in 1570, it has served as a retirement home for venerable ex-servicemen.

In the guildhall a fascinating video tells of the Black Book of Warwick, which contains most of what we know about Thomas's life, and is held in Warwick County

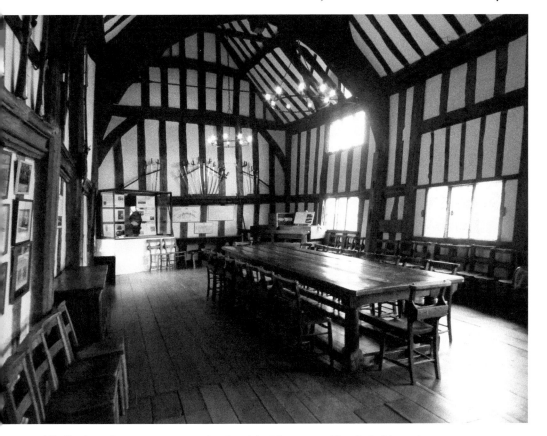

Guildhall of Lord Leycester Hospital, Warwick. (Courtesy of Jamie Robinson)

Image of Thomas
Oken in Lord
Leycester Hospital
exhibition, Warwick.
(Courtesy of Jamie
Robinson and Lord
Leycester Hospital)

Records Office. This book, written between 1565 and 1590 by the town clerk and bailiff John Fisher, contains eye-witness accounts that occurred in Warwick society in the 16th-century, along with the only speech of Oken's directly recorded, and a transcript of his will and the deeds establishing his charity. The original deed is in the County Archives with Oken's signature and seal.

The video, presented by actor David Troughton, highlights the connection between Thomas, the Black Book, and an ancient chest with many locks. It also describes the wrangle over his will and the dramatic circumstances surrounding the death of a man who ensured that the money he had gathered during his lifetime was to benefit many future generations.

As David Troughton says early in the film, 'Who was this exemplary man?' So we may very well see why it is that in the Thomas Oken Tea Rooms, each time she locks up, Jo has the sensation that there's still somebody in the building. 'Sometimes, when we have a group booking, we even leave a place at the table in case Thomas turns up.'

Kenilworth

Kenilworth Castle and Elizabethan Garden

> Our revels now are ended. These our actors,
> As I foretold you, were all spirits, and
> Are melted into air, into this air.
> And like this insubstantial pageant faded,
> Leave not a rack behind. We are such stuff
> As dreams are made on; and our little life
> Is rounded with a sleep.
>
> *The Tempest*, Act 4, Scene 1

When we enter the ruins of a once great castle, we occupy space alongside all the former inhabitants, though they and their lives may be 'an insubstantial pageant', having faded, melted into air.

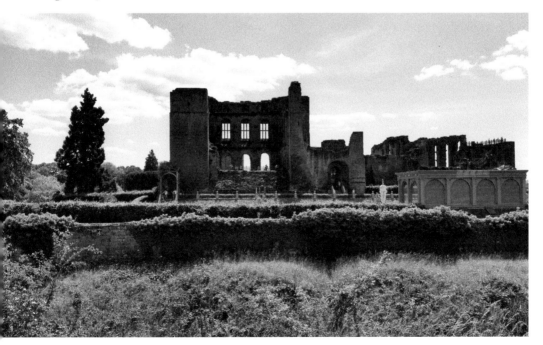

Kenilworth Castle. (Author)

The lord of the manor's table, from the Luttrell Salter (historical gravure plate).

Kenilworth Castle's rich and varied history never fails to fascinate, from the time Geoffrey de Clinton built the keep in the 1120s, right through the glory days of John of Gaunt's banquets in the 1390s, to 1649 when Colonel Joseph Hawkesworth blasted it after the English Civil War, and later moved in to live in Leicester's Gatehouse.

John of Gaunt's great hall saw many feasts, the walls covered with vibrant tapestries, blazing logs spitting and crackling in the great fireplace and the table laden with fragrant dishes and fine wines.

The castle passed into his hands in 1361. John was created Duke of Lancaster and fought long campaigns in France and Spain. In 1391 he set about converting the castle into a palace, and during the following eight years he held his great banquets.

Two centuries later, Sir Robert Dudley's guests arrived at Leicester's Building, specially constructed to house Elizabeth I and her entourage during their famous nineteen-day visit between 9 and 27 July 1575.

Sir Robert's father John, Duke of Northumberland, built the castle stables in 1553. Today they contain the tearooms and restaurant, and an exhibition of the castle's history. The stables are reputed to be haunted. Visitors describe the ghostly apparition of a young stable boy. Dressed in ragged clothes, he is thought to be around fourteen years old and of the period not long after the stables were built. He has been seen in three places: the stables, around Leicester's Gatehouse, and wandering among the ruins.

Other curious anecdotes are told by English Heritage staff, who claim to have heard voices from behind locked doors and felt presences in the kitchen.

In 1575 Sir Robert spent a vast amount of time and money preparing for Elizabeth's visit and his last attempt to persuade her to marry him. As part of his preparations, not only did he build the impressive accommodation block, but also he added the gatehouse. Today this is set up to look as it would have done in the 1930s, when it was used as a private residence. The top floor exhibition explores the royal love story between Elizabeth and Dudley.

Several strange tales emerge from Leicester's Gatehouse. Some visitors describe the apparition of a little girl who asks for her daddy. Others have witnessed a spectral

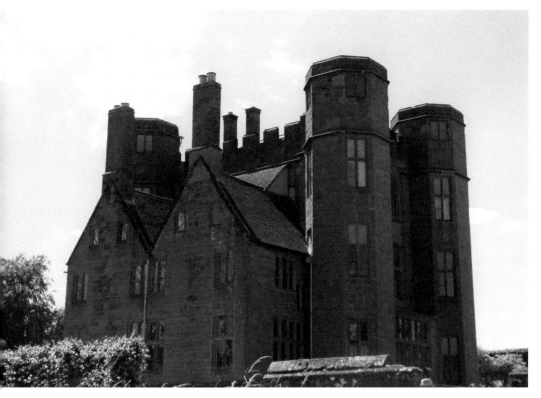

Leicester's Gatehouse, Kenilworth Castle, seen from the road. (Courtesy of Jamie Robinson)

man dressed in black who was killed in a swordfight. Further reported appearances include an old lady who breaks the same candle time after time.

Sir Robert abandoned all hope of marrying Elizabeth after she left in 1575 having evaded his proposals. In 1578 he married Lettice Knollys, one of Elizabeth's ladies-in-waiting, and the building was little used thereafter. Eighty years later Colonel Hawkesworth and the Parliamentarian troops stripped it and left it in ruins.

As for the Elizabethan Garden – created by Sir Robert to entice her during her 1575 visit – you may find it reimagined here today. Open to the public since 2009, the garden's design faithfully follows descriptions of the original by Robert Laneham, who was in the service of the Earl of Leicester. When Robert viewed it he memorised all the highlights, later noting them down. He described the garden as seductive, scented, brimming with colour and shrubs in full bloom, with its four obelisks and central marble fountain, and gemstone-studded aviary filled with lovebirds.

In the fields beyond the castle a circular arrangement of extensive banks and ditches denotes the site of the Pleasance in the Marsh. Henry V owned the castle during his reign from 1413 to 1422. He is thought to have built the Pleasance around 1414 on the furthest bank of the Great Mere: a luxurious manor house set in gardens, surrounded by a double moat with a harbour. The king would glide out of the castle in a pleasure boat together with his guests; they would moor the boat in the small harbour, and make their way to the banqueting hall for feasting and carousing, and to pass the merry hours of which Shakespeare speaks above.

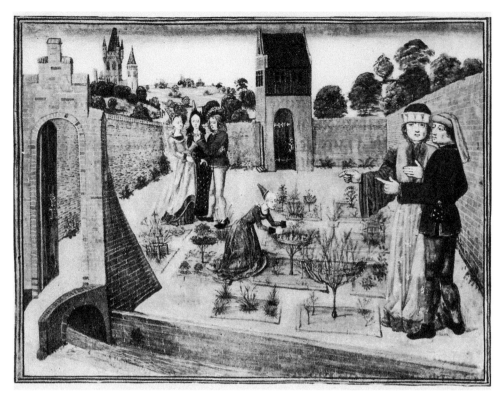

The Pleasance, French, late 15th-century.

Today open fields surround the castle, as Hawkesworth's troops breached the dam and drained the Great Mere in 1649 following the Civil War. All we may see is the evidence of the earthworks in the landscape, denoting the site of the former Pleasance.

As Shakespeare said, through the lips of Prospero in *The Tempest*, 'we are such stuff as dreams are made on'.

Abbey Fields

> Chanting faint hymns to the cold fruitless moon...

Theseus, the character who speaks the above words in *A Midsummer Night's Dream*, betrays a very negative view of life in religious orders as he threatens his errant child with the prospect. However, throughout the centuries in which the religious orders flourished, few of those who chose the monastic life would have thought it fruitless. For many it was their passion and their vocation, and so when Henry VIII dissolved the monasteries in 1538, it would have been devastating for all who spent their lives there.

St Mary's Abbey in Kenilworth gained its status in 1447, having previously been a priory for Augustinian canons. The abbey was dissolved in 1538, the monks dispersed and everything of value confiscated for Henry VIII's treasury. The Abbey Fields now provide a well-loved space for recreation, adjacent to the 13th-century parish church

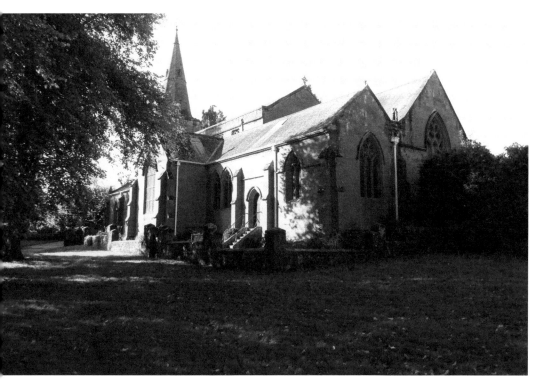

St Nicholas' Church, Kenilworth. (Courtesy of Jamie Robinson)

The lake in Abbey Fields, Kenilworth. (Courtesy of Jamie Robinson)

Path in Abbey Fields leading towards Kenilworth Castle. (Courtesy of Jamie Robinson)

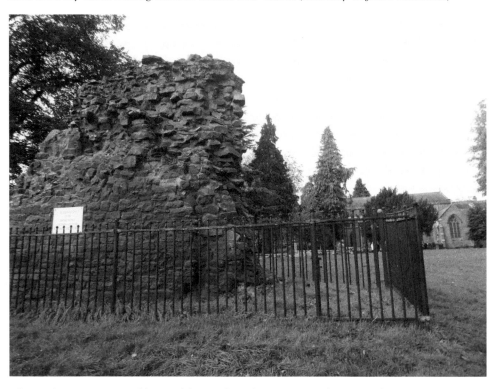

Chapter house remains, Abbey Fields, Kenilworth. (Courtesy of Jamie Robinson)

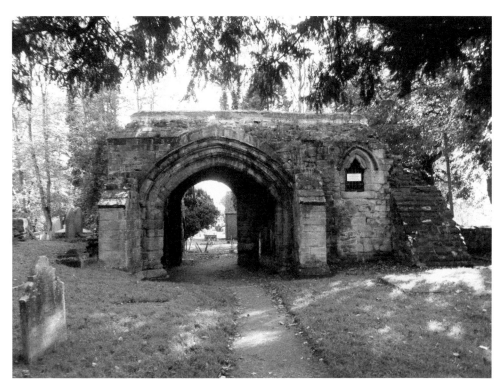

Ruins of abbey gatehouse arch, Abbey Fields, Kenilworth. (Courtesy of Jamie Robinson)

of St Nicholas. The Abbey Fields formerly contained the stew ponds where the monks bred fish for their tables. The Finham Brook runs through the fields and a popular walk may be taken along the path towards the castle.

Some of the cloisters remain, as do remnants from the former chapter house and also parts of the gatehouse and arch leading from Abbey Fields into the churchyard.

Curious incidents have been reported here, both in the area of the archway and in the graveyard. These include the feeling of being pushed, and the apparition of a black monk. One visitor described an eerie experience as she walked past that area late one evening. She saw three figures with hoods on, near the archway. She reports that the figures started coming towards her, at which she turned and fled.

Stoneleigh Abbey

> And as imagination bodies forth
> the forms of things unknown, the poet's pen
> turns them to shapes and gives to airy nothing
> a local habitation and a name.
> *A Midsummer Night's Dream*, Act 5, Scene 1

Stoneleigh Abbey, situated between Kenilworth and Leamington Spa near the village of Stoneleigh, is renowned for the colourful history of the Barons Leigh, and for its associations with two writers, novelist Jane Austen and poet Chandos Leigh.

Stoneleigh Abbey. (Courtesy of Jamie Robinson)

As we turn in at the entrance to the abbey, pass between the Grecian Lodges and make our way along the avenue, it is clear we are in a setting of precision and elegance. Crossing the rusticated stone bridge, we see ahead of us on the right the mellow stonework of the 14th-century gatehouse.

Passing through the gatehouse we emerge onto a winding path beside flower beds, and ahead of us arises an imposing, silver stone building surmounted with ornamental balustrades.

This is Stoneleigh Abbey, which occupies land granted to a group of Cistercian monks by Henry II in 1154.

The monks longed for a peaceful, tranquil piece of land and they found it here beside the River Avon. Building commenced in April 1156 and the rhythm of the Daily Office continued here undisturbed for over 400 years. That all came to a traumatic end with the Dissolution of the Monasteries. Following the departure of the abbot and monks, and the confiscation of all its lead and major timbers for the royal treasury, the abbey building spent twenty-five years as a roofless ruin.

Then it was sold to Sir Rowland Hill and his protégée Sir Thomas Leigh. It would remain in the hands of the Leigh family for the next four centuries, whose first move was to build an Elizabethan manor from the ruins, while later generations built around the cloisters. By the 17th-century it had become a sumptuous and richly furnished mansion. Among reported hauntings in the house, it is said that several past members of the Leigh family have made their presence known.

14th-century gatehouse, Stoneleigh Abbey. (Author)

Before the English Civil War, one member of the family, another Thomas, earned favour with King Charles I, whose cause he supported, and so, in return for a substantial donation to the Royalist cause, the king awarded him a baronetcy and he became the 1st Baron Leigh.

After the Civil War, as a Royalist, Thomas found himself in deep trouble. He was arrested and sent to the Parliamentary stronghold of Coventry. Once again Thomas's immense wealth saved him. His wife Anne paid £4,500 to Coventry to get him freed.

So over the ensuing generations the Barons Leigh flourished, until they reached Edward, the 5th Baron Leigh, the catalyst for a crisis in the Leigh family succession.

Edward became baron at the age of seven when both his parents died. After an illustrious academic career and a grand tour of Europe, this brilliant young man fell prey to what was then understood as 'a bout of lunacy or madness'. His greater misfortune was to find himself in the hands of Dr John Munro from Bedlam Lunatic Asylum in London, a self-proclaimed medic with no training, who may have caused Edward's decline with his ill-conceived treatments.

When Edward died, age forty-four, in 1786, his sister Mary inherited the property and for twenty years looked after the estate. Upon her death in 1806, unmarried and childless, someone had to be found to inherit the estate. It was offered to a Gloucestershire clergyman, Revd Thomas Leigh in Adlestrop, the sole descendent of a divergent branch of the Leigh family, from several generations before.

Thomas's cousin Cassandra and her two daughters had just arrived to visit Thomas as he received this news. Accordingly he invited them all to view his new inheritance, Stoneleigh Abbey, where they subsequently spent ten days. One of those daughters was novelist Jane Austen.

This was to be a highly fruitful visit for Jane, from a creative point of view. In the ten days she spent here, the house became Mansfield Park, the building at the back

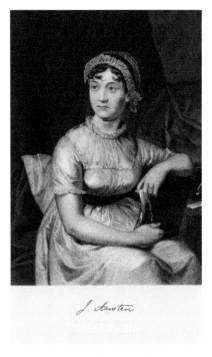 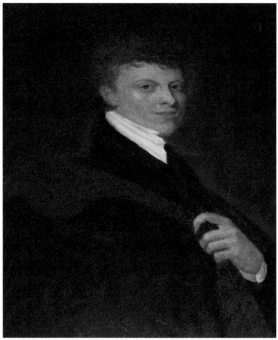

Above left: Jane Austen. (Library of Congress)

Above right: Chandos Leigh, a portrait in the Gilt Hall at Stoneleigh Abbey. (Courtesy of Jamie Robinson and Stoneleigh Abbey Charitable Trust)

became Northanger Abbey, and visitors may see here a portrait which would have inspired Jane for *Persuasion*'s Anne Wentworth.

Moving on from the saloon, through some of the other grand rooms, we reach the library. It is distinctive because it contains two chairs that represent the first professional work by a young apprentice aged fifteen: Thomas Chippendale. It is also considered to be the most haunted room in the house.

Above the fireplace hangs a portrait of Theophilus Leigh, renowned for changing sides on the question of whether or not to support William of Orange. Theophilus, with his wife Mary, had twenty-three children. Only three survived, of whom one, a boy called Thomas, was destined to become Jane Austen's grandfather.

The library was much loved by Chandos Leigh, poet, 1st Baron Leigh of the second creation. Chandos spent many hours writing and studying in here. He was the only son of James Henry Leigh (1765–1823), MP of Adlestrop, Gloucestershire, and subsequently of Stoneleigh Abbey, Warwickshire, by his marriage with Julia, eldest daughter of Thomas Fiennes, 10th Lord Saye and Sele.

Chandos published several books of poetry. His first publication, 'The Island of Love,' appeared in 1812. He followed this with 'Trifles Light as Air' in 1813. Among his other works we may find 'Poesy, a Satire' in 1818; and 'Epistles to a Friend in Town, Golconda's Fate, and other Poems' in 1826. His poems reflected the influence of Horace, Virgil, Pope and Byron, and were well-received by the literary establishment during his lifetime.

The Stoneleigh Abbey tour guide told us the following story.

I was doing a tour here – I was quite new at the time – and while I was speaking, the handle on that door over there started moving violently. It was really loud so I called, 'Stop!'

It stopped.

So I said to the manager, 'somebody's trying to get through that door, and you need to have a word with them as it really put me off my tour.'

'That's impossible,' he replied.

I said, 'I know it's impossible, the grandfather clock's standing in front of it, so they can't come in.'

'No no no, the other side of that door's a wall, the handle is only on your side. It really needs to be moved because it's stiff.'

Twenty people saw that. Last year we walked in and it was seven degrees in here and you could see your breath. You get other things in here too, lots of things. You walk in and you smell cigar smoke.

This is certainly a haunting story of the library that Chandos loved, where he studied and read and dreamed and wrote his poetry: the poetry that was prized only by a scholarly few, but never hit the big time, like his friends Lord Byron and Mary and Percy Shelley.

On my very first history tour of Stoneleigh Abbey, several years ago, our party passed through the room on the other side of the library. A different tour guide told us the following curious anecdote about the same door.

During a drinks reception held in that room not long before, a guest asked about the housemaid in old-fashioned uniform whom he had seen 'come out through that doorway'. He too was told that no door exists there. Several decades ago, the door was bricked up and incorporated into the wall.

The house, as mentioned before, is said to be haunted by many different spirits of the Leigh family. The following incident occurred in the recent past, not within the house, but in the Repton-designed grounds.

Field at Stoneleigh Abbey. (Author photo, Courtesy of Stoneleigh Abbey Charitable Trust)

Zara was visiting the abbey and gardens, and had crossed the bridge to stroll in the field on the other side of the river, which is part of the Stoneleigh Abbey estate.

> I stood at the edge of the Avon, enjoying the view. I became aware of a lady watching me from the other side of the river. I got the feeling she wasn't pleased with me being there, as she had a cross expression on her face. I noticed she wore a tweed outfit (similar to those worn by people hunting).
>
> I felt uneasy; she made me feel as if I was on private land, and she was the land owner. I decided, as she was still watching me, to cross over the bridge ten feet away and apologise to her.
>
> To my great surprise as I got to the end of the bridge and looked left to where the lady had been stood moments before, there was nobody there. I was absolutely terrified and I ran away as fast as I could. I have no idea who the lady was but she certainly gave me the impression I wasn't meant to be there.

The apparition seen by Zara may have been any of the ladies of the house who resided at Stoneleigh Abbey after Chandos's son William took over the barony in 1850. The Barons Leigh continued to hold Stoneleigh Abbey until 1996 when the 5th Baron, John, transferred ownership to a charitable trust. Much of the property is now occupied by private residents, but the orangery and gardens, the chapel, undercroft, saloon, grand rooms and of course Chandos's much loved library remain open to the public as a treasured historical destination.

Bridge at Stoneleigh Abbey. (Courtesy of Jamie Robinson and Stoneleigh Abbey Charitable Trust)

Stratford-upon-Avon

The Royal Shakespeare Theatre

> All the world's a stage
> And all the men and women merely players.
>
> *Henry V* Prologue

> What, a play toward! I'll be an auditor:
> An actor too, perhaps, if I see cause.
>
> Puck in *A Midsummer Night's Dream*,
> Act 2, Scene 1

The Royal Shakespeare Theatre stands on the waterside in Stratford-upon-Avon, on the same piece of land formerly occupied by Shakespeare's garden when he lived at New Place from 1597 to 1616.

In 1875, the then owner Charles Flowers donated the site to the newly created Shakespeare Memorial Theatre Ltd Incorporated.

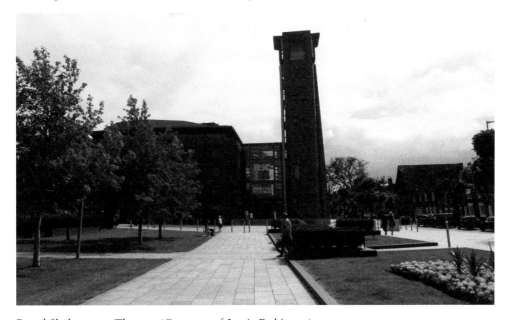

Royal Shakespeare Theatre. (Courtesy of Jamie Robinson)

The theatre itself opened four years later. Following its destruction by fire in 1926, its fortunes soon rose again with the appointment of a young architect, Elisabeth Scott, who was commissioned to design a new theatre on the site adjacent to the burnt-out building. Some of the theatre fraternity think Elisabeth still makes her presence known here today.

Her new theatre opened in 1932. Twenty-eight years later the Royal Shakespeare Company was established, and the building renamed the Royal Shakespeare Theatre. In the early 1980s the original burnt-out shell of the Victorian building was converted to the Swan Theatre.

But no matter the changes to the building, the ghostly apparitions persist.

In 1995 the Transformation Project was first proposed. The plans were met with strong resistance from devoted theatregoers and actors alike, for whom the theatre was a spiritual home. To pull down the original fabric of the building that had resonated to the voices of so many renowned actors seemed like sacrilege.

Many of the present-day actors insisted that part of the original fabric of the old theatre should remain, not only as an act of homage to the history of the Elisabeth Scott theatre, but also in response to their feeling that somehow the spirits of their great predecessors were absorbed into the fabric of the building. So when work began in late 2007, the Relic Wall was preserved, and remains there today, adjacent to the Riverside Cafe on the ground floor and a predominant feature of the Rooftop Restaurant, covered with posters of productions from the time of the Elisabeth Scott theatre.

Also, an urn containing the ashes of Sir Ian Richardson (who died on 9 February 2007) was placed into the foundations of the auditorium during this renovation. So the theatre was transformed.

It seems that many who have loved this theatre in their lifetimes cannot turn away from this magical and evocative place. Ghost stories emanate freely from the building, judging by the ease with which the theatre staff tell them.

A grey lady is often seen. She appears so real she is often mistaken for a lost theatregoer. She is thought by many to be the spirit of Elisabeth Scott, and she is one of the theatre's most well-known ghosts.

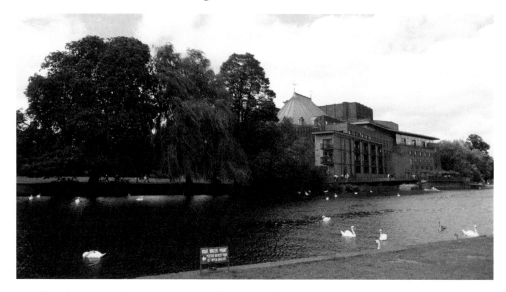

Royal Shakespeare Theatre. (Courtesy of Jamie Robinson)

Pippa, a former retail merchandiser at the theatre, said,

> I was opening up in the old Swan shop on a Sunday morning, which included unlocking the Swan Gallery doors and turning all the lights on. Whilst in the gallery, I looked at an old RSC costume, and I remember feeling cold, but nothing out of the ordinary. When I returned to my colleague, she said she was surprised to see a visitor viewing the gallery so early in the morning. I said it was only me up there, but she insisted she saw a lady standing behind me while I looked at the costume. The lady wore a long grey dress, and it was all captured on CCTV; however, I knew there was no-one else in the room but me.

Another regular encounter at the theatre continues to be the perfumed lady. She has been observed by front of house staff in the Upper Circle and is a frequent presence around the Swan Theatre, switching the bridge lights on again no matter how many times they are switched off, and checked to be in perfect working order.

One of the stage managers recalls an occasion when audience members were filing into the auditorium just before the play was due to start. A man casually walked from the foyer to the backstage area. Staff tried to stop him, thinking he was someone who didn't know where to go, and was heading in the wrong direction. However, he disappeared.

The stage manager and her colleagues believe he was the ghost of an actor who knew the backstage area very well.

Nash's House and New Place

Love is like a child,
That longs for everything it can come by.
The Two Gentlemen of Verona, Act 3, Scene 1

Nash's House is next door to Shakespeare's own home, New Place, in Chapel Street. Formerly Thomas Nash lived there, who became the first husband of Shakespeare's granddaughter Elizabeth. Elizabeth was the only one of Shakespeare's four grandchildren that he knew personally, as the others were born after his death in 1516. He knew Elizabeth up until the age of eight, when, following his death, Elizabeth moved with her parents Susanna and John to live in New Place.

That manor house, Shakespeare's own family home, which he bought with his London money, and where he wrote his later plays, no longer exists because it was demolished in 1759 in a fit of spite by Revd Francis Gastrell, the impetuous priest who owned the property and got so fed up with the Shakespeare tourists, he decided to burn the house down.

In destroying it, he did of course have mixed motives: besides being annoyed by all the tourists, he was also trying to avoid a tax on the property. After he had demolished the house he fled Stratford, his taxes still unpaid, and never returned, thus evading justice for what may be considered one of the worst ever acts of historical vandalism.

It is speculated that many of the remaining timbers may have been removed by the townspeople and some are thought to have ended up in the Falcon Hotel opposite, which is now known as the Hotel Indigo.

Next door, Nash's House, may have a ghostly resident. One evening a builder was investigating an alarm that had triggered unexpectedly. After completing all his checks on

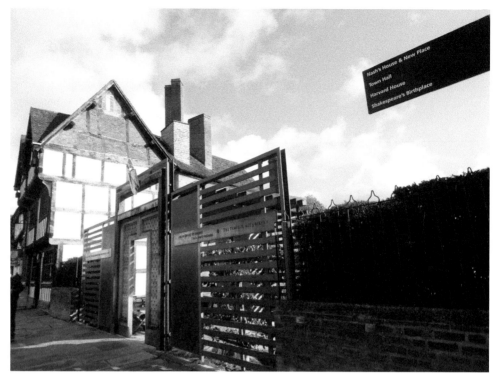

Nash's House and New Place, Stratford-upon-Avon. (Courtesy of Jamie Robinson)

the first floor and finding no obvious fault, he went down the stairs. 'The stairs were uneven and dark, so he lit his path by taking photos on his phone; the flash guiding his way.'

He still found no obvious reason for the alarm to have gone off. Later he looked at his photos, and on one he saw that he had captured

> in the right hand side of the photo, near the bottom of the staircase ... a little boy's face with a white collar and sleeves.

Holy Trinity Church

> Good friend for Jesus' sake forbeare
> To dig the dust encloased heare
> Bleste be ye man y spares thes stones
> And curst be he y moves my bones.
>> The curse on Shakespeare's grave

> O bid me leap, rather than marry Paris,
> From off the battlements of any tower...
> Or hide me nightly in a charnel house
> O'ercovered quite with dead men's rattling bones,
> With reeky shanks and yellow chapless skulls
>> Juliet, from *Romeo and Juliet*, Act 4, Scene 1

The church most closely associated with Shakespeare stands beside the River Avon near the ford from which Stratford takes its name. The north entrance of the church may be approached along a path of slabs comprising ancient gravestones, in a churchyard full of historical graves.

The slender spire of the church may be discerned from afar, and it is the church in which Shakespeare was baptized and where he was buried.

His grave is famous for the curse engraved upon it, forbidding anyone to move his bones.

It is thought Shakespeare may have been motivated by the number of times he had seen bones removed from old graves here and thrown into the charnel house – the door can be seen close to his monument, though the charnel house itself no longer exists. It is mentioned in *Romeo and Juliet*, as Juliet declares she'd sooner spend the night there, rather than be forced to marry the man she does not love, County Paris.

Up until the present day, despite strong incentive to defy Shakespeare's curse, nobody has dared to do so. Among a few scholars, doubt persists about the true authorship of Shakespeare's works. Some have applied for access to his grave to discover whether, as is rumoured, manuscripts lie buried with the bard, which might confirm the truth of the matter once and for all. So far no one has been allowed to disturb that grave. The power of the curse holds.

Though Shakespeare was imbued with knowledge of the Bible, which is seen throughout his plays, his own private beliefs remain a subject of scholarly debate, to be glimpsed through the words of his characters.

Nevertheless, this church may well be considered his spiritual base. Thousands flock to Holy Trinity every year for the sole purpose of visiting Shakespeare's grave

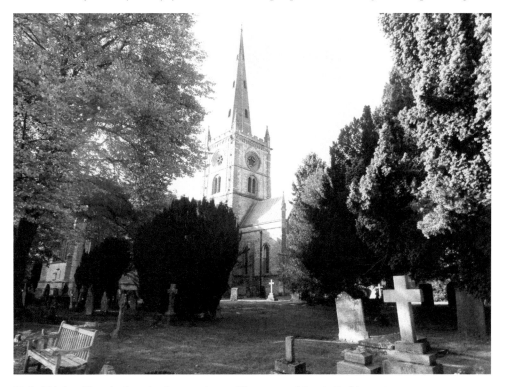

Holy Trinity Church, Stratford-upon-Avon. (Courtesy of Jamie Robinson)

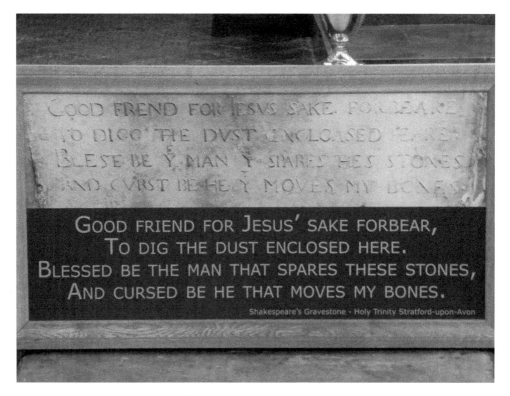

Above: Curse on Shakespeare's grave, Holy Trinity Church, Stratford-upon-Avon. (Courtesy of Jamie Robinson)

Left: Charnel house door, Holy Trinity Church, Stratford-upon-Avon. (Courtesy of Jamie Robinson)

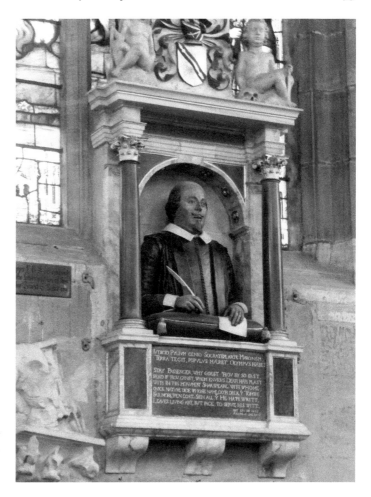

Shakespeare's monument, Holy Trinity Church, Stratford-upon-Avon. (Courtesy of Jamie Robinson)

in the chancel. Alongside him lie the remains of his wife Anne, his daughter Susanna, son-in-law Dr John Hall, and Thomas Nash, the first husband of his granddaughter Elizabeth. It is thought that the bones of other family members – Elizabeth, his daughter Judith, her twin brother Hamnet, and Judith's husband Thomas Quiney, lie instead beneath the turf in the churchyard.

Shakespeare's writings retain their power because he was quick to draw all the emotional, psychological and spiritual resonance from any true-life event he came across. One such event may have given him the idea for Juliet, young and beautiful, laid to rest in the Capulet family tomb, apparently dead, but in fact still alive.

This story concerns the Clopton family, commemorated in an elaborate chapel at the north side of the church before you enter the chancel. The family lived at Clopton House a short way up the road from the church.

The sad story begins when young Charlotte Clopton, following a sudden illness, appeared to have died. Her funeral was held at Holy Trinity, and her coffin placed in the family crypt.

Some months later her mother died, and again a funeral was held and the crypt opened to admit her. At this point they discovered the body of poor Charlotte slumped against the wall. She had awoken from her catatonic state and fought her way out of

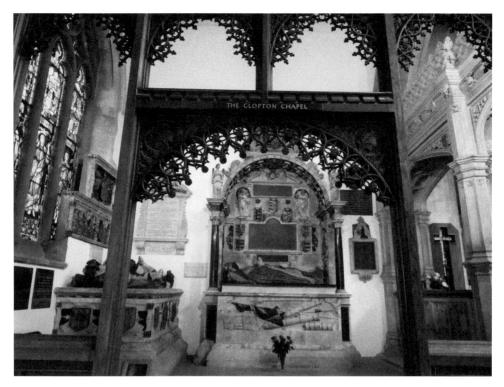

Clopton Chapel, Holy Trinity Church, Stratford-upon-Avon. (Courtesy of Jamie Robinson)

her coffin, but had been unable to break out of the tomb. She had evidently survived some time, traumatised and distressed, before she died of starvation.

In Charlotte's case, stories abound of her unquiet spirit haunting the area. She is said to haunt a particular room in Clopton House.

Another possible connection between the church and the works of Shakespeare focuses upon the scene with the gravedigger in the churchyard in *Hamlet*. Hamlet sees bones being dug up to make way for Ophelia's grave, and is handed a skull, which, he is told, belonged to Yorick, whom Hamlet had known as a young child. 'That skull had a tongue in it and could sing once,' laments Hamlet.

The church enjoys the iconic status of centre of pilgrimage, along with the Shakespeare Birthplace in Henley Street. Every year on the Saturday closest to the anniversary of Shakespeare's birth, 23 April, a procession of bands, dancers, actors, clergy, international diplomats, townspeople and schoolchildren makes its way through the town and into the church, all carrying flowers. The procession is always led by boys from Shakespeare's former school, King Edward VI School, and rosemary is worn for remembrance, as offered by Ophelia in *Hamlet*. The next day a special service is held here, in which musicians and actors of the Royal Shakespeare Company take part.

As we leave the church through the north porch we emerge back into the churchyard, turn right and walk to the riverside. There we may for a time, perhaps, set aside the horror of poor Charlotte Clopton's end, the fear and dread in Juliet's heart as she imagined the charnel house, or the grim warning of Shakespeare's curse, and instead rest on one of the benches and watch the life of the river and listen to the rushing of water over the weirs to the south.

Ettington Park Hotel

> I can call spirits from the vasty deep.
>
> *Henry IV Part I*, Act 3, Scene 1

The manor of Ettington Park has been held by the Shirley family since the Domesday Book in 1086 and possibly long before. This Gothic mansion is now a luxury hotel, and is situated six miles south-east of Stratford-upon-Avon. It has the reputation of being one of Warwickshire's most haunted locations.

A priest is known to have served at Ettington at the time of the Domesday Book. The remains of a medieval church stand in the grounds of the present hotel, some parts of which date from the 12th and 13th centuries, with an early 13th-century transitional tower left complete.

Local lore has it that Shakespeare hunted at Ettington, along with members of the Underhill family who leased the manor from the Shirleys for a hundred years.

On 29 June 2006, a BBC report appeared describing paranormal investigations carried out at Ettington Park. On that occasion, Martin Winch joined BBC Coventry and Warwickshire's Paul Marriott and Revd Mervyn Roberts for 'an evening of ghost busting at the very haunted Ettington Park Hotel. Did they spot any spooks?'

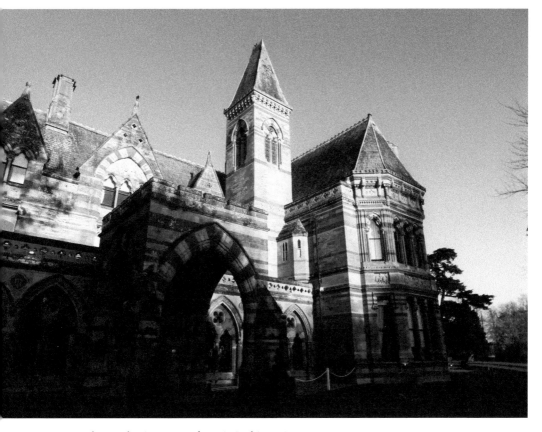

Ettington Park Hotel. (Courtesy of Jamie Robinson)

Medieval church remains, Ettington Park. (Courtesy of Jamie Robinson)

Many ghostly incidents are reported at the hotel – apparitions and poltergeist phenomena among them. Michael Kenny worked at the hotel as a night manager for five years from 1997 to 2002. He describes his experiences as below:

In the banqueting and conference room we have a cold spot. One night I was preparing for a meeting the following day. Suddenly the atmosphere changed and became terribly cold. My own body temperature dropped slowly. I began to feel ill, so I decided to stop what I was doing and go to the kitchen to warm myself up by one of the ovens. This is a familiar experience to visitors and staff alike.

In room 7 one warm summer night, a guest decided to get up and go to open the window to let some air in. Out of the window you can see across to the adjacent wing, rooms 10 and 11 and a corridor. He saw a lady in what appeared to be evening dress walking down the corridor. He didn't think too much about it and went back to bed.

Then in the gap under his door, he saw the feet of somebody standing outside. He opened the door and was confronted by a lady dressed in Victorian style clothes, white cap, long grey dress; she seemed terribly distressed. It was clear to him she wasn't a living person. Shocked, he at once closed the door.

We think this apparition is associated with two children who drowned in the river Stour. She goes around looking for them; she was probably their governess.

Michael offers his own explanation for the events at Ettington Park:

> If you take a CD, what are you doing? Are you not replaying real events and emotions just as they happened at some time in the past and were recorded on basic materials to be replayed time and again at a future date?
>
> Is it not possible that certain materials, given the right conditions, can have human events impressed or recorded upon them? Then, at some later date, again given the right conditions or atmosphere, a person walks into that environment and becomes the medium by which the recorded events are replayed. The ghostly phenomenon known to us as haunting then occurs.

Paranormal investigators Stephen and Simon tell me that Lady Emma is the main apparition seen in the hotel. Certain areas of the building are said to become intensely cold with no rational explanation. Also the figure of a man in 17th-century clothing is seen inside and outside one of the rooms with a dog.

> It's a big black dog, which appears to both staff and guests. People see him, whereupon he disappears. On the stairwell, some report the feeling of being pushed. Others see a candlestick hovering in the air. Many smell pipe tobacco in the Long Room. In addition, people claim to have seen the two children who it is believed drowned in the River Stour.

Stephen and Simon have also investigated ghostly incidents in the medieval church: 'If you look at the church,' said Simon, 'there is a point at the bottom of the tower which is under cover, but still open to the elements. There I saw a black figure watching us. The figure walked from one side of the space to the wall on the other side, and disappeared.'

CHAPTER FOUR

Lapworth

Baddesley Clinton Manor

It is an honour 'longing to our house
Bequeathed down from many ancestors.
All's Well That Ends Well, Act 4, Scene 2

The medieval moated manor house of Baddesley Clinton has been bequeathed down from the many ancestors whose stories haunt it. The 15th and 16th centuries in England produced great cultural treasures, among them a style of architecture we now prize: the timbered house, built with wattle and daub, with big open fireplaces, exposed timbers and flagstone floors.

Baddesley Clinton house was built in 1400. Its name derives from a Saxon called Baeddi, who first cleared the site in the Forest of Arden where the house stands, and the de Clinton family, who dug the moat in the 13th century.

For 500 years the house was owned by the Ferrers family, passing from father to son for twelve generations. The Ferrers family remained loyal to the Catholic faith despite periods of persecution.

Edward Ferrers built much of what we see today, from 1526 onwards. Henry Ferrers, who lived at Baddesley from 1564 to 1633, rented the house to various tenants when he was away from Baddesley.

Most notable among his tenants were the two Vaux sisters. Anne (1562–1637) and her sister Eleanor loved their Catholic faith, and they rented the house in order to host gatherings of Jesuit priests during a period of fierce anti-Catholic persecution. It is thought that Henry never knew the use to which Anne and Eleanor were putting his house. While tenants there, they even commissioned Nicholas Owen, the master priest hole builder, to construct three hiding places for priests.

Nicholas designed the priest holes and built them by hand. He evaded capture for some time but after his final arrest, he was tortured to death in the Tower of London (and, centuries later in 1970, was canonised by the Roman Catholic Church). One priest hole is hidden in an old toilet, another is off the Moat Room, and a third leads into the ceiling.

Anne was devoted to Father Henry Garnet (1555–1606), a regular guest at Baddesley Clinton. One of his fellow Jesuits, Father John Gerard, recorded a raid in the early hours of 19 October 1591 in a house in Warwickshire, which was probably Baddesley Clinton. The servants, together with Anne and Eleanor, held the priest-hunters off, while seven priests disappeared from view. The raid lasted for four hours and no priest was discovered.

Later, however, Father Henry Garnet was captured. He was hanged, drawn and quartered in 1606.

Among the apparitions at Baddesley Clinton, there appears a 15th-century priest. He served the church in safer times, politically: before the Reformation. However, these times were not so safe for him personally, as we will learn. His name is given as Willelmus Foster on the register of rectors of the parish of Baddesley Clinton, to be found in St Michael's Church. In 1485 the hot-headed lord of the manor, Nicholas Brome (1450–1517), found Will in the parlour, 'chocking his wife under the chinne'. Having misinterpreted the priest's intentions, he drew his sword and killed him.

Visitors to Baddesley Clinton used to hear the tale of the bloodstain on the library floor and relate it to the priest's murder. However, the murder took place in 'the parlour'. It is now thought the library hadn't even been built at the time, so the supposed bloodstain remains a mystery.

Will wasn't replaced for another eight years, when Alexander Awen became parish priest. This interregnum allowed Nicholas ample time to make amends, and it seems he succeeded. Instead of suffering a death sentence, he did penance, and built two church towers. One was the tower of the church at Baddesley Clinton, and the other was the church at nearby Packwood. Together they are sometimes known as the 'Towers of Atonement'.

Register of Rectors, Baddesley Clinton Church. (Courtesy of Jamie Robinson)

Above: Tower, Baddesley Clinton Church. (Courtesy of Jamie Robinson)

Left: Nicholas Brome in stained-glass east window of Baddesley Clinton Church. (Courtesy of Jamie Robinson)

If you go into St Michael's Church at Baddesley Clinton, you will find that Nicholas is celebrated there for his repentance and piety. He's commemorated in the stained glass of the east window, kneeling in prayer. Nicholas, we learn, was worried about his eternal soul following the murder of the priest. He became a member of no less than eight religious fraternities, praying each day for the souls of its members.

The focus on repentant Nicholas has the effect, of course, of imprinting him in people's memories much more than the priest he murdered.

As a children's verse declares (in a booklet to be found in the church):

> Upright he was buried; 'neath a mat he'll be found,
> As penance, where people will tread;
> As you enter the church you're inevitably bound,
> To step on poor Nicholas's head.

Another apparition sometimes seen in the manor house is that of a lady who wears a long grey, black or dark green dress and carries a candle. She wanders the upstairs rooms, and also appears in the Great Hall.

Some have suggested she is the apparition of Rebecca Ferrers, former owner of the property, who died in 1923.

Other ghostly incidents include footsteps along the upper landing. They have been heard by the sceptical property manager, walking towards his office. They were also

The Quartet in Baddesley Clinton Manor. (National Trust)

reported by Rebecca Ferrers herself during her lifetime. In addition, Rebecca saw 'the door handles turned by an unseen hand'.

In addition to footsteps, heavy breathing, tapping, thumping, knocking on the walls and even tearing cloth have been reported in the house.

Other ghostly incidents include watering cans being upset in the library, mugs of soup flying up into the air in the stewards' room, and plates falling to the floor and breaking, all with no observable cause.

National Trust staff report that the portrait of a young officer with a white belt across his chest has appeared where no portrait ever hung before. In a wide gilded frame, glowing with its own light, it floats across the room before disappearing. Could it be the portrait of Major Thomas Ferrers, who was killed when he fell from the ramparts at Cambrai where he served in 1817?

Other visitors claim to have seen a man in a red velvet jacket and white belt who is thought also to be the ghost of Major Thomas.

In the 1930s a visitor saw the family dog begging 'to no one in particular'. The family joke insisted that the dog was 'begging to the ghost'.

Gifted artist Rebecca Orpen (1830–1923) came to live here in 1867 with her husband Marmion Edward Ferrers. Two years later her aunt Georgiana, and Georgiana's husband Edward Dering, joined her, but Edward was the man whom Rebecca really loved.

The four became known as 'The Quartet' and filled their lives with poetry, painting, writing and music. Rebecca was a gifted artist. After seven years Georgiana died, followed eight years later by Marmion. Rebecca and Edward then married and continued to live at Baddesley.

The house is full of stories. Its stained-glass leadlight windows display family coats of arms; disappearing staircases once led somewhere but no longer do, because of later structural alterations, which have created surprising elements and unexpected 'dens'.

Baddesley Clinton manor captivates with its beauty and with the poignant stories that have become absorbed within the fabric of the building and given rise to some of its ghosts.

Alcester

Coughton Court

O conspiracy,
Sham'st thou to show thy dangerous brow by night,
When evils are most free?

Julius Caesar, Act 2, Scene 1

Approaching Coughton Court, the ancestral seat of the Throckmortons, we may admire the mellow sandstone 16th-century house with its dramatic battlemented gatehouse tower and timbered north and south wings. Behind the house is an Elizabethan-style garden with abundant seasonal planting.

Everything about this house and its surrounding grounds speaks graciousness, fine proportions and serenity. However, that has by no means always been the case; for this house has known betrayal, terror and conspiracy.

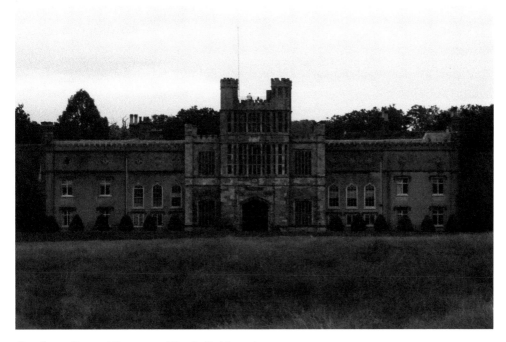

Coughton Court. (Courtesy of Jamie Robinson)

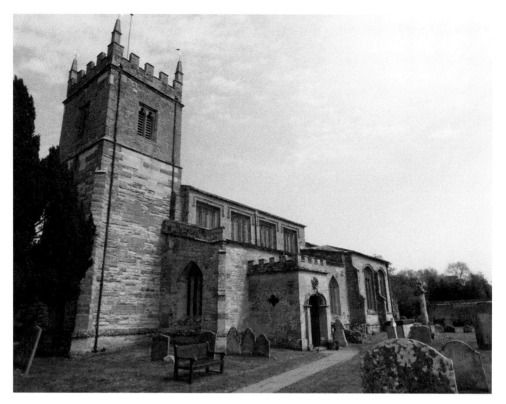

St Peter's Church, Coughton Court. (Courtesy of Jamie Robinson)

The Throckmortons held Coughton Court for more than 600 years before the National Trust took over ownership. During that time the vast majority of the family have been fervent Catholics, remaining loyal through times of great persecution. Several generations of the Throckmortons have become closely involved in major events in English history.

The first Throckmortons to own land in Coughton were John and Eleanor in 1412. A later family member, Robert, was knighted in 1494 along with Prince Henry, the future Henry VIII, thus beginning the family's long and fateful association with the Tudor monarchy.

Robert's son George opposed Henry VIII in his attempt to divorce Katherine of Aragon. Later Henry forced him to attend Anne Boleyn's coronation. Next George thwarted Thomas Cromwell in a land dispute, and later served as prosecution witness at Thomas's trial and thus finding himself in a perfect position to seal his fate.

Later, Nicholas stands out among the Throckmortons as the sole Protestant in the family. We might wonder how that affected family relationships.

He had a very narrow escape when his support of Lady Jane Grey ended in defeat. He spent time in prison after opposing Queen Mary's marriage to Philip of Spain. He acted as confidant to the young princess Elizabeth, brought the news of Queen Mary's death to her, and acted as her emissary to Mary Queen of Scots. All of this failed to win for him the high office at court that he had hoped for.

After Nicholas's death, the family resumed its activities on behalf of the Catholic side with renewed zeal. In 1584 his nephew Francis was executed for trying to depose Elizabeth and place Mary Queen of Scots on the throne.

In the year 1700 Lucy Throckmorton had her portrait painted. She wore a gold coloured dress trimmed with blue, over which she draped a voluminous blue stole.

All we know about Lucy is written on the canvas above her portrait: 'Daughter of Clement Throckmorton, & Wife of Wm Bromley Esq of Bagington, & afterwards of Mr Chester.'

As was the practice at the time, women were to be identified only in terms of their relationships with the men in their lives.

The following incident occurred on Bank Holiday Monday in August 2014. Karen was visiting the churchyard of St Peter's Church, close to the house at Coughton Court, when, as she relates:

On the left side of the gate, I noticed a woman in a goldy brown/bright blue dress, very old fashioned, with long dark hair, staring down in dismay at what would have been a gravestone. She didn't seem happy. I thought she was an actor in costume dress, as they sometimes have at National Trust properties.

While Karen was looking at her, the lady disappeared. Karen said that the apparition lasted several seconds, long enough for her to notice what the lady was wearing, her hair and the fact that she disappeared in front of Karen's eyes.

'It was quite a profound experience,' added Karen.

Left side of gate into St Peter's churchyard, Coughton Court. (Courtesy of Jamie Robinson)

Later she toured the house. Imagine her astonishment when she found herself looking at the portrait of Lucy Throckmorton – and recognised the lady she had seen in the graveyard.

The house is also associated with the Gunpowder Plot, in which family members were involved. Lady Digby, the wife of Gunpowder plotter Sir Everard Digby, sat in the drawing room here, awaiting news, together with two priests, Nicholas Owen (the master priest hole builder), and the Vaux sisters from Baddesley Clinton. When they learned of the failure of the plot, they quickly dispersed, and, of course, the plotters all met their deaths in different grim and grisly ways.

Despite this traumatic episode, the family were to persist in their Catholic devotion for centuries after, right down to the present day.

Tragedy in 1914 provided the backdrop for another uncanny incident at Coughton Court. In the early years of the 20th century, the heir to the estate was Richard Courtenay Brabazon Throckmorton. The family coat of arms surmounted the entrance arch to the gatehouse, a proud reminder of the unbroken lineage of the Throckmorton baronets.

In the house you may find the original post office telegraph from the Secretary of the War Office, addressed to Mrs Throckmorton:

Deeply regret to inform you that Lieut Col. R.C.B. Throckmorton of the Wiltshire
Regiment was killed in action 9th April. Lord Kitchener expresses his sympathy.

Local folklore and Throckmorton family tradition both claim that at the moment of Richard Courtenay's death the stone shield fell from the coat of arms on the Tudor gatehouse, an omen that he had fallen in battle.

He had been the heir to the estate and son of the 10th Baronet. The damaged crest has never been put back up; it rests within the gatehouse. His widow never married again. She was later to be responsible for ensuring the property was passed to the ownership of the National Trust.

Rugby: A Famous School and Much-loved Sport

The town of Rugby saw a major reversal of its fortunes, following several centuries as a modest farming settlement. Registered in the Domesday Book of 1086, it existed here as an Anglo-Saxon hamlet known as Routbie.

Above: Rugby School. (Courtesy of Jamie Robinson)

Right: Lawrence Sheriff plaque in Rugby. (Courtesy of Jamie Robinson)

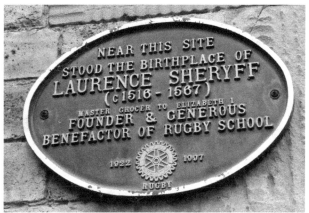

Over the years, it slowly grew until, following the Industrial Revolution, it experienced swift growth with the arrival of railways. In 1838 an early part of what later became the West Coast Main Line was built around the town. Soon after that, many wagon works and engineering facilities were opened.

The town is, of course, also famous now for Rugby School, and for the sport of rugby, which originated at the school. The town boasts a Pathway of Fame, a collection of bronze plaques that celebrate legendary players and pivotal moments in rugby's history.

Rugby School itself was founded by 14th-century philanthropist Lawrence Sheriff, who is commemorated in many different ways around the town. As Rugby's benefactor, he reminds us of his contemporary Thomas Oken, who holds a similar place in history in relation to the town of Warwick. Lawrence, like Oken, was a wealthy Elizabethan merchant. He left his fortune to the endowment of the almshouses and Rugby School.

Inevitably much has changed over the centuries, but the centre of Rugby is full of historical character and atmosphere. Matthew, Rugby tour guide for Ghosts Unlimited UK Ltd, has accumulated many colourful and fascinating stories about this town during the course of his research. In the following chapters, I recount some of Matthew's curious tales.

Chapel Street, Rugby

On the corner of Chapel Street sits the oldest building in present-day Rugby: a 14th-century shop which once housed Tew's the Butchers. Tew's place in history was secured when author Thomas Hughes mentioned it in his 1857 novel *Tom Brown's*

The former Tew's and the Black Swan, Rugby. (Courtesy of Jamie Robinson)

Schooldays for supplying the piece of beef steak with which Tom Brown nursed a black eye after a fight with 'Slogger' Williams. The story is set in the 1830s in Rugby School. Hughes attended the school from 1834 to 1842. The novel was originally published as being by 'an old boy of Rugby' and much of it is based on the author's experiences.

Adjoining this 14th-century shop is a terrace in which may be found The Black Swan, a popular local inn. In the 18th and 19th centuries these terraced properties were all one, but later, walls were constructed to separate them. The buildings are reputed to be haunted, with several reports of figures floating through the walls.

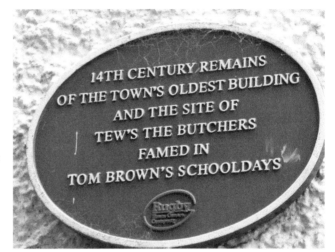

Right: Historical plaque about Tew's, Rugby. (Courtesy of Jamie Robinson)

Below: The Black Swan, Rugby. (Courtesy of Jamie Robinson)

Matthew says:

When we carried out paranormal investigations in the Black Swan, we heard many stories. Staff and customers describe items falling off the shelves, cold draughts or breezes, together with the awareness of a little girl wandering around; and an apparition of a big man with a dominant manner – possibly an ex-landlord. Several reports refer to a dark shadow walking through the wall into what is now The Copper Tree.

The pub staff tell me they don't like to go into certain rooms; they feel very uncomfortable, as if they're being watched. Some report the sound of a woman screaming; others complain about shadows on the floor.

Research has uncovered the fact that a serious accident took place here in 2002, when a wall fell, and a woman was killed.

Church Street, Rugby

If we walk back along the street and turn left, we will find ourselves at the clock tower, with the Crown pub on our left. The building across the road in Church Street was formerly occupied by the Lawrence Sheriff Almshouses. The workhouse was a short distance away on Lower Hillmorton Road.

The almshouses were based in one substantial, three-story building, but at a later time, this was converted into smaller liveable houses.

The row of shops that we see today on this site is said to be haunted. Many report seeing shadows walking through walls, or simply disappearing in front of their eyes. Others feel they are being watched, or sense that someone else is with them when they are alone in a room, or hear the sound of shuffling feet. Footsteps are often heard

The Crown pub, Rugby. (Courtesy of Jamie Robinson)

The former almshouses, Church Street, Rugby. (Courtesy of Jamie Robinson)

on the upper floors. In the building now occupied by H. Samuels, reports include 'a strange presence' upstairs, and feelings of being pushed and touched. Many agree that those upper rooms are always very much colder than any of the other rooms.

Theatre

On Henry Street you will find Rugby Theatre. In 1946 the Rugby Amateur Theatre Society was formed with the intention of founding a permanent theatre in the town. This was achieved in 1949, when the society obtained a former cinema on the current site and set about converting it into a theatre.

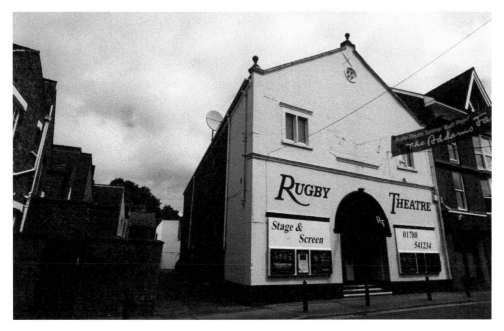

Rugby Theatre. (Courtesy of Jamie Robinson)

One of the stories told here is of a woman seen floating down the stairs. It is thought she was an usherette in former times, who is still taking tickets and escorting theatregoers to their seats once they have come past the box office.

Another story concerns the Circle. This is believed to be haunted by the apparition of a man who fell over the balcony and died. He loved the theatre so much he is often seen in his former seat, and people have actually got out of his way as he moved towards it.

His is not the only apparition that lingers around the theatre. Another, witnessed several times, is thought to be that of a man whose love for the theatre draws him back here. Many have also reported hearing voices in the changing areas below the stage and seeing shadows moving across the stage.

Castle Street

If we walk to the end of Henry Street and turn right, we will move toward Castle Street on the left.

In 1890 one of the properties in Castle Street was the scene of a family tragedy. In a fit of rage, one William Gosse killed his daughter, Sarah-Anne. Following this crime, he went on the run for a couple of days, but was eventually arrested and charged with her murder. The inquest and trial were held at the Crown pub, where William was judged insane and sentenced to life imprisonment.

Castle Street, Rugby. (Courtesy of Jamie Robinson)

Nowadays, some passers-by report strange experiences in Castle Street, where William lived with his wife and daughter. They claim to hear wailing and screams from William's wife, and to see shadows in the windows, usually at around seven or eight in the morning, the time of the murder.

High Street

If we return to the town centre and walk along the High Street, we may find a very popular shop: Yum Yum World. It was once the Town Hall for Rugby, before the council moved premises to their current site. Many strange tales have emerged from this property. Reports include the sound of meetings taking place, and apparitions of men in suits sitting in rows.

Returning to the other side of the high street, a little further on, we will see Poundland. The building it currently occupies, and the one next to it, together also formed the original town hall for Rugby. The upper floors here are thought to be haunted too. Some report seeing a grey lady who walks the upper floors and creates a feeling of unease.

Back again on the other side of the High Street we see the Lawrence Sheriff pub, where customers and staff often get a very cold feeling and report that the hairs on their arms stand up, without apparent reason. Down in the cellar, the temperature is often exceptionally cold, and it is claimed electrical items turn on and off by themselves.

YumYum World, Rugby. (Courtesy of Jamie Robinson)

Poundland, Rugby. (Courtesy of Jamie Robinson)

Lawrence Sheriff pub, Rugby. (Courtesy of Jamie Robinson)

St Andrew's Church

As we return to Church Street we see ahead of us the magnificent parish church of St Andrew. St Andrew's has stood at the heart of Rugby since the 14th century, with the church's west tower believed to be the town's oldest structure. The church's other tower, designed by William Butterfield, was added in 1895.

The town's benefactor, Lawrence Sheriff, is believed to have lived in one of the houses opposite the church. A very wealthy grocer, he supplied royalty including the Princess Elizabeth, who was later to become queen in 1558.

When Lawrence Sheriff died, it was expected that he would be buried within the precincts of St Andrew's Church, but some family members objected and he was buried in Christ Church Greyfriars, formerly in Newgate Street, opposite St Paul's Cathedral in London. Sadly, there remains no trace of his burial, as that church was burned down during the Great Fire of London.

Strange experiences are reported in St Andrew's graveyard and the adjacent gardens. Some claim to see shadows or hear voices and screams.

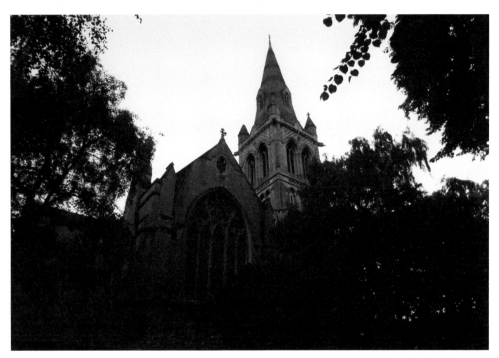

Above: St Andrew's Church, Rugby. (Courtesy of Jamie Robinson)

Right: St Andrew's churchyard, Rugby. (Courtesy of Jamie Robinson)

St Andrew's Gardens, Rugby. (Courtesy of Jamie Robinson)

Flying from the plague, broadside on the flight of townspeople to the country.

The area behind the church dates back to 1130 to the reign of King Stephen. Here, we now find peaceful gardens, containing a number of historical gravestones. Formerly, it is said, this land was occupied by a manor house protected by guards. Reports here include the apparition of a tall man wearing a black tall hat, a black coat and black shoes. Some walkers in the gardens say they hear whispering and voices.

In the 1630s one of the periodic outbreaks of bubonic plague hit England. It is hard for us to imagine the terrible distress of those times, though we may read about it in certain eloquent contemporary accounts, or see it recreated for us at historical sites. In 1634 the death toll in Rugby rose dramatically. Many would have been buried in a large pit in St Andrew's graveyard.

Wolfhamcote: Deserted Medieval Village

The Black Death had first appeared in England in 1348. From then on it spread throughout the British Isles, and periodically ravaged the population, right up until the end of the 17th century. Near Rugby, the village of Wolfhamcote was deserted at the end of the 14th-century.

This tiny hamlet has four surviving buildings: a cottage, a farmhouse, the old vicarage, and a church that stands in the middle of a field. Visitors to the church, will find a rich, poignant atmosphere. It has been restored several times, most recently in the 1970s by an organisation called the Friends of Friendless Churches. It is today managed by the Churches Conservation Trust and is used only once or twice a year.

Local legend maintains the village was abandoned because all inhabitants died from the plague. It is suggested that plague sufferers from Rugby, Northampton and Coventry were taken to Wolfhamcote to die.

This may, however, not be strictly true, according to the historical record. It may be some people were left alive after the plague had departed, struggled to make a living in the village, and then drifted away to seek work in the towns, leaving the lord of the manor to turn the land over to sheep grazing.

Wherever the historical truth may lie, this tiny hamlet and church is reputed to be haunted, and several visitors have reported seeing shadows and ghostly apparitions there.

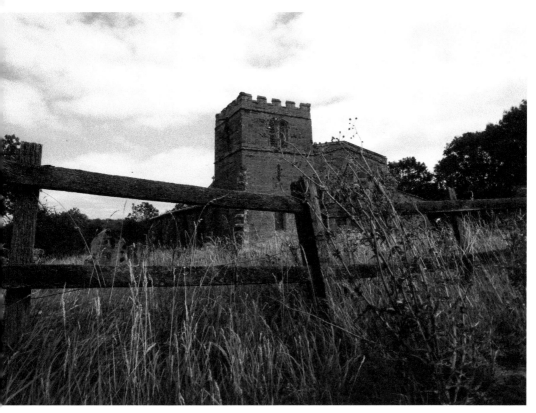

Wolfhamcote Church. (Courtesy of Jamie Robinson)

Nuneaton: Birthplace of George Eliot

Nuneaton, famed for its association with the great 19th-century novelist George Eliot, is the setting for some curious stories from those who formerly held sceptical views.

George Eliot is herself an intriguing example of that, through what is known of her life and literary output. She was born Mary Ann Evans in 1819, the same year Queen Victoria was born. Her birthplace was South Farm on the Arbury Hall estate. Her father Robert worked as the land agent for Arbury Hall, which brought him into touch with miners, weavers, farmers and aristocracy.

In 1820 he moved his family to Griff House (now a Beefeater restaurant on a traffic island). George Eliot spent her childhood and teenage years here. Growing up, she observed with a keen eye the extraordinary aspects of ordinary people, and in adulthood she became a radical intellectual, defying not only social convention but also orthodox religious beliefs.

Later she settled in London, where she stayed until the end of her life in 1880. She visited Warwickshire for the last time in 1854, and yet her fictional world remained strongly influenced by and deeply rooted in Warwickshire.

George Eliot, 19th-century novelist. (Library of Congress)

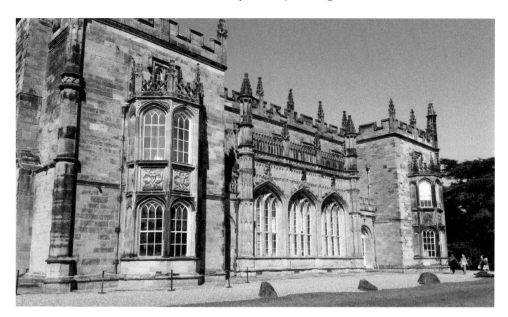

Above: Arbury Hall, Nuneaton. (Author)

Right: Griff House, Nuneaton. (Author)

The Griffin Inn, Griff

Not far away from the home where George Eliot spent her childhood and adolescence is The Griffin Inn, one of Nuneaton's haunted locations, and it is very likely she visited it several times.

The Griffin Inn is a historic pub, a relic of the old days of Griff and Chilvers Coton. Given a victualling license in 1654, pubs such as this were, as they are now, centres of village life and George Eliot would have visited with family members during the period in which she lived at Griff House.

The Griffin has now been renovated with a new bar and restaurant, but an unexplained visitor continues to haunt the inn.

In 1995 the then licensee awoke to hear the frantic barking of his dog. He saw the tall figure of a veiled woman in his room. Thinking it an intruder he leapt out of bed and hurried to turn the light on, but it disappeared.

The Griffin Inn, Nuneaton. (Author)

Previously in the pub there had been mysterious bangs and knockings, and in the cellar compressed air cylinders and beer taps were frequently found turned off. An earlier landlord and his partner had seen an old lady in black sitting on the end of their bed.

The ghost is agreed to be a lady in Victorian dress but her identity has never been discovered.

No. 62 Queens Road

> Cassius: You know that I held Epicurus strong
> And his opinions; now I change my mind,
> And partly credit things that do presage ...
> Their shadows seem
> A canopy most fatal
>
> *Julius Caesar* Act 5, Scene 1

George Eliot is known to have been a radical intellectual; her novella *The Lifted Veil* (an example of the Victorian horror genre), published in July 1859, is unique among her works for its supernatural premise. It explores themes of extra-sensory perception, the essence of physical life, the possibility of life after death, and the power of fate.

I suggest that if George Eliot had been alive and writing her novels today, she would have been keen to bring her spirit of enquiry into the extraordinary series of events reported by working people in the premises at Queens Road, Nuneaton.

Queens Road, formerly the main street of the town, was split into two parts by the Nuneaton ring road. In Queens Road, strange events are reported by the staff of several retail businesses – and none more so than those working at No. 62. Angela, the former lessee, reports a series of strange events there that have persisted for decades.

Angela first bought No. 60 Queens Road in order to start up a business with her partner Dawn, selling video games and movies.

Having made a success of this, they leased No. 62 and turned the business into a big two-floor music store. Entertainment Exchange opened in 1994 and became the biggest music, gaming and film collectors store in the West Midlands. At the height of the business Angela and Dawn employed twenty-five staff on their rota. As from 2014, they no longer owned or operated from either of these two buildings.

Both buildings are extremely historic and atmospheric. Angela's account focuses on No. 62 where she traded for twenty years.

Angela arrived at her store the day before it was due to be opened, when she spent four hours upstairs alone in the shop, with the door to the street locked, pricing vinyl and laying out displays. As she was putting LPs in racks, she saw something out of the corner of her eye: the image of 'a small dumpy woman dressed in black, with dark hair which she wore in a bun at the back of her head'. Startled, Angela turned her head to the woman, but the image vanished in front of her.

Following this experience, she decided to keep the incident to herself and say nothing to anyone else about it. She maintained her silence on the subject for the next three months.

During this time she frequently smelt old-fashioned pipe tobacco and furniture polish in the shop, lost sight of items from places where she knew she'd left them, and occasionally glimpsed somebody or something out of the corner of her eye.

One day her colleague Dawn asked Angela if she'd ever experienced 'anything odd' in the music shop. It turned out that Dawn had also seen, in exactly the same place upstairs, the same woman glimpsed by Angela. They agreed to share any further odd incidents with each other but not with the staff.

Then staff members started to come forward and confide in Angela that they had also encountered the figure in their peripheral vision, heard footsteps on the upper floor after closing time, and lots of noise coming from the storeroom area.

Angela's new manager, Robert, joined the business as a convinced sceptic. He was forced to change his mind after repeatedly feeling that an invisible person had pushed past him. One day, he witnessed 'a full-on apparition of a male at the end of the upstairs floor'. It seemed to shimmer; and disappeared.

Nos 60 and 62 Queens Road, Nuneaton, 2019, premises formerly occupied by the Entertainment Exchange. (Courtesy of Jamie Robinson)'

Over the next few years the strange events persisted. These included the frequent false triggering of the alarm, always caused by something upstairs; the sound of heavy running footsteps late in the evening coming from upstairs; a heater found plugged in first thing in the morning that had been left unplugged the night before; and racks of CDs left tidy by the last person in the shop at night, and found half-empty the next morning with CDs thrown around.

Members of staff continued to share stories with Angela. One particular girl, Teresa, changed her hair on a daily basis. One day it would be a pink Mohican and the next it would be a green skinhead. One lunchtime in the staff kitchen, a man approached and stood very close to her. He stared with intense curiosity at her hair, and vanished. Not long after this, Teresa handed in her notice.

As the years passed, mail order became more important to the business, and Angela would spend several evenings a week upstairs on the computer.

> It wasn't long before things started to happen. As I sat at the computer the peripheral vision shapes escalated. After hours the activity seemed to increase; more than anything the atmosphere upstairs seemed as thick as fog. One night I was looking for a particular address and felt as if everything around me was shimmering. I had the feeling I could slip or disappear into another world or time zone, the air felt so thick.

Terrified, she picked up her mobile and called Dawn, asking her to come and get her at once.

Before long, Angela and Dawn handed the lease of No. 62 back and the property reverted to the landlord. However, in her first conversation with the new manager at No. 62, Angela discovered the ghostly incidents were continuing apace.

She began to gain some insight into the history of the building when she met a local news photographer. He told her he had worked here himself at No. 62, when it was a photography studio. During that time,

> we all knew it was haunted. We got to the stage where we refused to work after 6pm as we felt something was trying to get us out of the shop.

Angela discovered the female figure that she and Dawn had seen fitted the description of the lady who had managed the photography studio for many years.

And this was by no means all that Angela discovered when she researched the history of the building, which had been a draper's store during the Second World War. A tragic account lay in the archives of the *Nuneaton Tribune*. The 16 and 17 of May 1941 was the night of the Great Blitz in Nuneaton. During the war, Nuneaton was often targeted by the Luftwaffe, intent on bombing the munitions factories, and the town suffered heavy damage. No. 62 had received a direct hit that night, the most traumatic in Nuneaton that century; where the upstairs extension now was, there had once been a shelter that had received a direct hit and been obliterated.

As we read Angela's story, we may well recall Hamlet's words to his sceptical friend:

> There are more things in heaven and earth, Horatio
> Than are dreamt of in your philosophy

I think we might be inclined to agree with him.

Leamington Spa: A Fashionable Regency Health Resort

Give me leave
To speak my mind, and I will through and through
Cleanse the foul body of the infected world,
If they will patiently receive my medicine.
As You Like It, Act 2, Scene 7

Though tracing its origins back to the Domesday Book of 1086, the town of Leamington Spa owes its most noteworthy character to its decades as a highly fashionable health spa in the 18th and 19th centuries. Favoured by royalty at that time, it continues to celebrate the memory of an illustrious medical man, Dr Henry Jephson.

Long before Dr Jephson's time, however, there existed here a hamlet called Lamintone, which in medieval times was owned by Kenilworth Priory. The small village came to be known as Leamington Priors.

A view of the Parade, Leamington Spa, from the gates of Jephson Gardens. (Author)

In the early 1700s, the 4th Earl of Aylesford discovered a mineral spring on his land and made it available for anyone to use, for free, south of the River Leam.

Then a gentleman by the name of William Abbotts discovered a second mineral spring on his land in 1784. That land, where William subsequently set up his bath house, Abbott's Bath, is now occupied by Majestic Wines.

It was William's friend Benjamin Satchwell who changed everything. We might now think of him as 'Leamington's PR man', for he wrote in glowing terms about the healing properties of the water at his friend's well. Upon the publication of his report in London, many wealthy and influential visitors headed for Leamington in the Prince Regent Stagecoach.

From then on, Leamington's fame grew, and seemed to achieve the highest status when in 1808 the beautiful and famed Duchess of Gordon arrived. The duchess was the envy of society at the time and star of the gossip columns. As soon as it became known that she and the Duke of Bedford were in Leamington to take the waters, this sealed the town's status as a fashionable destination for the higher echelons of society.

Elegant Regency buildings and hotels sprang up to accommodate all the aristocratic visitors. Some of those hotels were built with Bertie Greatheed's money, as was the case with the Royal Pump Rooms, which were built by a consortium including Bertie in 1814.

A fashionable health spa or resort, of course, needed a medical man of high repute. Leamington Spa had one: Dr Henry Jephson, a much sought-after and brilliant physician.

In 1830 the eleven-year-old princess Victoria and her mother the Duchess of Kent visited the town. Victoria was delighted with all she saw, and when she became queen seven years later she was pleased to bestow the title royal upon Leamington Spa.

In 1902, a year after her death, in honour of the town's happy association with Queen Victoria, a statue of her was erected outside the Town Hall.

Several colourful characters are associated with Leamington Spa. Top of the list comes Dr Henry Jephson himself, whose curative diet might appeal to some of us today. His diet sheet included plain meat, plain pudding, butter and Madeira, the only alcohol he allowed. But he forbade fruit and vegetables. However, curiously, he himself kept the best vegetable garden in the district.

He also recommended that his patients should take the waters three times a week, but no more, as it would then do disastrous things to them. In addition, he prescribed plenty of exercise. This was eagerly taken up by his wealthy patients who could kill two birds with one stone by promenading about the place in their finery, being seen.

Dr Jephson also ran his own national health service, because every day he gave two hours of free consultation to the people of Leamington.

Another colourful character in the town's history at that time was Jack Mitton, an extraordinarily rich young Shropshire man. A talented horse rider, he nevertheless took enormous risks. One of his acquaintances bet him that he couldn't ride his horse in through the front door of the Bedford Hotel, up the stairs, jump over the dining room table on the first floor through to the balcony, and down into the street. This he did.

The hotel is now occupied by the Leamington Spa branch of HSBC. I wish I could say a phantom horse and rider is seen galloping through the banking hall today – but sadly not.

Leamington Spa, though, by no means lacks strange tales elsewhere in the town.

The Railway Station

It is in the railway station that we may find some ghostly presences. Throughout the 18th and early 19th centuries, travellers could only reach Leamington Spa by Crown Prince Stagecoach, and the journey from London took nine hours. That all changed in 1844 with the formal opening of the Warwick & Leamington Branch Railway, and the first railway station in the town. This brought Leamington Spa within four hours journey of London.

The station building was replaced in 1852. Posters advertised the town as a 'Modern Holiday and Cure' resort. In 1939, despite initial negative reaction stirred up three years earlier by the local press, the Great Western Railway opened an art deco station to replace the original building of 1852. The building is listed Grade II.

Both passengers and station staff report ghostly incidents. Stephen Herbert was night-time security officer there from 2012 to 2016.

> It was about two thirty in the morning. I was walking through the underpass to get to Platform Two. I turned round to see a dark shadow behind me. I said, 'stop following me. You don't need to do this. Move away from me.' But it got really close to me. I continued up the stairs, and when I turned round at the top, it was gone.

Stephen has several other curious tales to offer from night times spent in the station after it has closed to passengers.

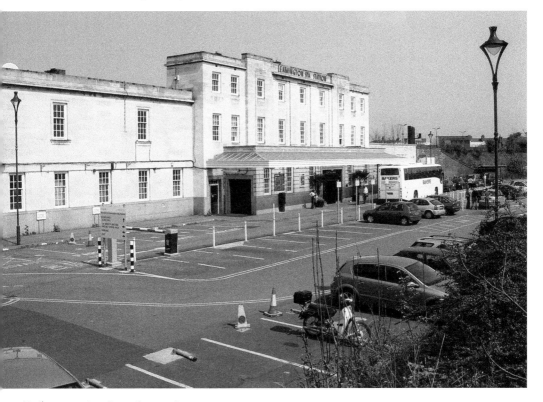

Railway station, Leamington Spa.

LEAMINGTON'S DOOMED STATION

This block of buildings known as Eastnor Terrace, was demolished to make way for the existing G.W.R. Station,—which is now to be rebuilt.

Historical news cutting of 1936 about Leamington Spa railway station. (Courtesy of Warwickshire Libraries)

Platforms one and two at night, Leamington Spa railway station. (Courtesy of Jamie Robinson)

I went into the room which is now the cafeteria. An engineer came in with me. We heard three massive thuds like someone hitting the wall with a solid jack hammer. On another occasion, at about three or four in the morning, I saw a lady across the tracks on Platform Two. I challenged her.

'Excuse me, what are you doing in the station? How did you get in here?' She looked at me as if she'd heard me, turned away and carried on walking. I ran down to the underpass, along and up the stairs to find her, and she had gone. So I got onto the CCTV; there was nothing there, although I had seen her clearly. I had to make a phone call to report her so as to make sure there was no danger of someone being on the track. We have to cover ourselves.

Another time, I was walking around when I saw that a door I had previously locked was standing open. So I went to check the door. It was on Platform One. The door slammed on me as I went to it. I thought it must have been the wind, and locked it.

A lot of paranormal activity takes place in the offices upstairs: doors opening and closing with no explanation.

This is confirmed by other members of staff, who regularly see and hear things upstairs, including doors slamming and electrical equipment turning on and off by itself.

One staff member said,

When we first moved into the top floor offices, the previous occupants had obviously left in a hurry. I regularly have paperwork thrown about. Doors are left open and I hear footsteps. I find it is often a quick way to end a meeting, having a door slam for no logical reason. I've now learned to live in harmony with the ghosts.

On another occasion, Stephen responded to a report of a woman wearing brown in a part of the station closed to the public beyond the bicycle racks on platform two.

When I got down there she'd gone. There are six foot fences with barbed wire. I worried that it might be a trespasser, so I waited and waited; but she didn't reappear.

Stephen also describes ghostly incidents in the basement.

When I went down the stairs on my own, the weirdest thing I've ever seen floated out of the wall: a mass of white light which hovered in front of me. On other occasions, I've walked down there and have been pulled on the arm. It's now a store-room for the cafeteria.

A rail journey is a time of transition. So perhaps we may speculate that energy and memories have imprinted themselves here at this railway station. Indeed, another of Stephen's curious tales features the presence of a man who used to work here during the age of steam as a wheel tapper.

Built in 1880, at a time when the town's spa days were almost over, the station saw steam trains come through, about which many feel nostalgic, and perhaps some, though not all, may associate the most carefree hours of their life as those in which they made rail journeys.

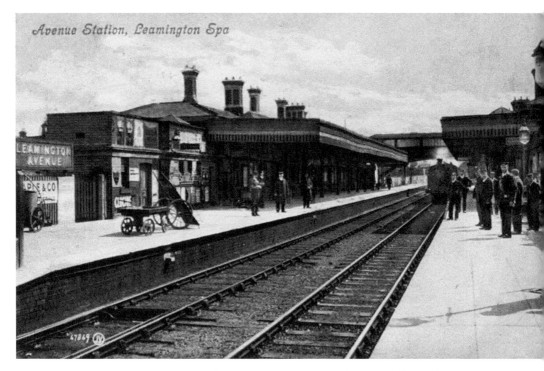

Steam train at Leamington Spa railway station. (Courtesy of Warwickshire Libraries)

Victoria House

Another location in Leamington Spa where strange tales abound is Victoria House, otherwise known as the Masonic Rooms. Situated on the corner of Upper Holly Walk and Willes Road near the centre of town, this elegant building was constructed in 1835.

Today the owners hire it out for conferences, special events and weddings. It has housed a banker, a vicar, a ladies' academy, and the Freemasons since 1889, whose chapel occupies the top floor. During the Second World War, the Polish and Czech armies in exile set up their headquarters in the town; Czech soldiers were garrisoned in Victoria House. You will find a memorial to some of their soldiers in the Jephson Gardens.

Stephen said:

> The Freemasons themselves, who are all retired and in their 80s, have shared a number of stories with me. They believe that a German prisoner of war may have been murdered here, and his body lies buried under the slabs beneath the house.

Certainly, a number of ghostly incidents seem to be concentrated on the cellar.

Curious sightings elsewhere in the house include the figure of a bearded man in 17th-century dress at the top of the stairs; two shadowy figures glimpsed in a basement room; and the apparition of a captain from the Second World War. Ghostly footsteps are reported coming up the stairs, and a few curious tales centre upon the Freemasons' chapel on the top floor.

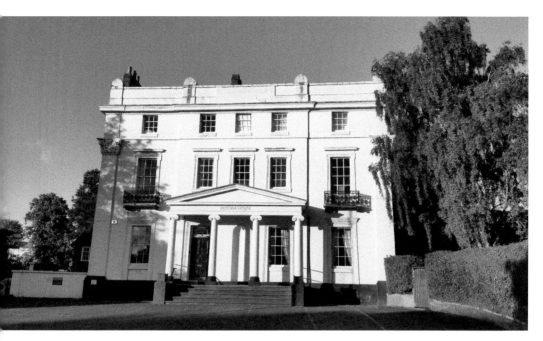

Victoria House, Leamington Spa. (Author)

It seems that the Freemasons who live in Victoria House have plenty of stories to tell, many of which they may have kept to themselves until paranormal investigations in the property brought them to light.

Leam Terrace

In the 1830s, as we have seen, wealthy and aristocratic visitors from London favoured Leamington Spa as a fashionable destination.

Behind All Saints Parish Church may be found the elegant Leam Terrace, built in 1830 during the reign of William IV, in the same year that eleven-year-old Princess Victoria visited the town.

Lucy formerly owned one of the properties there. She says:

We moved into the house in 1997 with two very small children and two cats. Periodically the cats would come into our ground floor family room with its high ceilings, at the back of the house, and look up to a point on the wall about eight feet off the floor, and they'd snarl and hiss. It didn't bother us; it was simply something we noticed about the cats.

Seventeen years later, we sadly had to sell our family home following the breakdown of our marriage. We made the property look as nice as we could, believing it to be a very desirable property; but it wasn't selling. Everybody was saying different things. It was nothing consistent that you could put your finger on in terms of why it wasn't selling. My feeling grew stronger and stronger that some spirit there was blocking the sale.

I decided to ask my friend Jeanette to help. She's in Christian ministry, and leads spiritual retreats. She agreed to come and pray and bless the house, to rid it of any

Leam Terrace, Leamington Spa. (Courtesy of Jamie Robinson)

negative spiritual presence. We started in the room where the cats had this negative reaction. I put my hand facing that spot and felt as if my chest and neck were being constrained; and I had to get out. Jeanette prayed for me outside, and then I felt better.

We went upstairs, intending to work through every room. First, we entered the main bedroom, and prayed in the area nearest the door. After that we walked around the bed to the ensuite bathroom; I looked at Jeanette and asked, 'Did you smell that?' and she said, 'Yes I did.'

What had happened, when we got around the bed it was as though we had walked past somebody wearing perfume. I had never smelt that in there before, in all the time I'd lived there. It feels as though by setting out to do what we were doing, we had brought the presence into a clearer form.

We went back to that space and prayed again, and continued around the house.

I had moved out by this time and was living in a rented house until the sale went through. However, I returned every day to make sure everything looked nice. So I went back a day or so later, and again I could smell that smell.

I lay on the bed and had a conversation with the room. I said we had done everything to preserve the integrity of the house, but we could no longer afford to live here. We needed to move on, and pass it onto somebody else who would also be a good custodian of the house. Whatever it was in the room, would they understand that and facilitate that.

I asked for more prayers of blessing in the house over the next week. Within days of this we had an offer. The sale was completed. To my knowledge the people living there now have never expressed anything about this to the neighbour I'm still in touch with.

As for the corner of the room downstairs where the cats reacted, for me the explanation is that somebody had hanged themselves there, because that's the height that it was, higher than somebody standing.

My own researches among local news reports for the period of the house's history failed to uncover a suicide by hanging in this house, although I did come upon a report in the *Coventry Evening Telegraph* dated 12 February 1965 about a suicide by hanging in a house further up Leam Terrace. That, of course, does not in itself exclude the possibility that a similar tragedy also took place here in the 19th or 20th centuries.
Jeanette speaks of the story in these terms:

Lucy told me a corner of the bedroom felt cold and strange. I sensed that too. I felt a negativity; not full of light and love and wholeness. We focused on praying there. She believed prospective buyers had picked this up, which was why the house wasn't selling. I agree with her on that.
I have some Celtic prayers of blessing for a home, and so we prayed for the cleansing of whatever was there, and for anything that was not of God to go; that God would fill it with his peace and love, so that it would become a place that was positive and full of hope and goodness.
I believe places hold the emotional charge of what's happened there. Psychological disturbance in the past inhabitants leaves an echo – and that may sometimes include what we call 'unquiet spirits'.

So perhaps, reflecting on Jeanette's words and all the stories recounted here, we may leave the final remarks to that 'shrewd and knavish sprite' Puck, also known as Robin Goodfellow, in *A Midsummer Night's Dream*.

> If we shadows have offended,
> Think but this, and all is mended,
> That you have but slumbered here
> While these visions did appear.
> And this weak and idle theme,
> No more yielding but a dream ...
> So, good night unto you all,
> Give me your hands, if we be friends,
> And Robin shall restore amends.

Acknowledgements

Every attempt has been made to seek permission for copyright material used in this book. However, if we have inadvertently used copyright material without permission or acknowledgement, we apologise and we will make the necessary correction at the first opportunity.

The author and publisher would like to thank the following people and organisations for permission to use stories and photographs:

Adrian King, custodian of Guy's Cliffe, Warwick
Coral Pavitt for her story of Maddie and Michael at the Saxon Mill, Warwick
Ghosts Unlimited UK Ltd for stories told by Liam, Warwick town guide, and Matthew, Rugby town guide
A Gathering of Ghost Hunters for stories told by Stephen Herbert and Simon Powell, paranormal investigators
Stoneleigh Abbey Charitable Trust for story told by the Stoneleigh Abbey history guide
Johanna Hobbs, proprietor of the Thomas Oken Tea Rooms, Warwick
Lord Leycester Hospital, Warwick
Lesley G. Shepherd, spiritual tutor and author of *A Diary Through Spirit*
Karen Spence for her story at Coughton Court
Angela Collings for her story of No. 62 Queens Road, Nuneaton
Lucy and Jeanette (not their real names) for their story of Leam Terrace, Leamington Spa
The Collegiate Church of St Mary, Warwick

Bibliography

Bates, Professor Sir Jonathan, *Shakespeare's Ancient Ghosts* (United Kingdom, PDF document published online: Gresham College, 27 March 2019)

Cornwell, Paula, *Stoneleigh Abbey* (United Kingdom: Pitkin)

Dixon, Bob, *Guys Cliffe: Back to Its Roots* (United Kingdom: Bob Dixon, 2002)

Evans, Sian, *Ghosts: Mysterious Tales from the National Trust* (United Kingdom: National Trust Books, 2006)

Garnett, Oliver, *Coughton Court Warwickshire* (United Kingdom: National Trust)

Hemingway, Vincent, *Coughton Court and the Throckmortons* (United Kingdom: Coughton Court and Jarrold Publishing)

Horsler, Val, *Holy Trinity Church, Stratford-upon-Avon: A Visitor's Guide to Shakespeare's Church* (United Kingdom: Holy Trinity Church and Third Millennium Publishing, an imprint of Profile Books Ltd)

King, Tony, *The Collegiate Church of St Mary Warwick* (United Kingdom: Pitkin Publishing)

Morris, Richard K., *Kenilworth Castle* (United Kingdom: English Heritage)

Pattison, Mike, *The Tale of Nicholas Brome* (United Kingdom: Mike Pattison)

Porter, A. F., *A Short History of St Mary Magdalen Chapel, Guy's Cliffe, Warwick* (United Kingdom: A. F. Porter)

The Shakespeare Birthplace Trust, *Shakespeare: Work, Life and Times – Official Guide* (United Kingdom: Jigsaw Design and Publishing Norwich)

Trevelyan, G. M., *Illustrated English Social History* (Great Britain: Longmans, Green & Co, 1944)

Warwick Castle Ltd, *Warwick Castle: Britain's Greatest Mediaeval Experience* and *Warwick Castle: The Essential Guide* (United Kingdom: Warwick Castle Ltd)

Historical Gravure Plates

Trevelyan, G. M., *Illustrated English Social History* (Great Britain: Longmans, Green & Co., 1944) for:

image 4, 'John Rous, chantry priest of Guy's Cliffe near Warwick, compiling the Warwick roll', ms in the possession of the College of Arms, illustrated with coloured drawings executed between 1477 and 1485 by John Rous;

image 41, 'The lord of the manor's table', the Luttrell Salter; image 43 'The formal garden or lady's pleasaunce', French, late 15th century;

image 88, 'Flying from the Plague', from a broadside in the possession of the Society of Antiquaries on the flight of townspeople to the country.

Websites

nationaltrust.org.uk/baddesley-clinton

www.stratford-herald.com/92341-warwickshire-spooky-insist-paranormal-experts.
 html

https://www.shakespeare.org.uk/explore-shakespeare/blogs/ghost-nashs-house
 'A Ghost in Nash's House?' 30 Oct 2015

www.spookyisles.com/clopton-house-ophelia

BBC Coventry and Warwickshire Ettington Park ghost busting

www.bbc.co.uk/coventry/content/articles/2006/06/29

www.warwick-castle.com